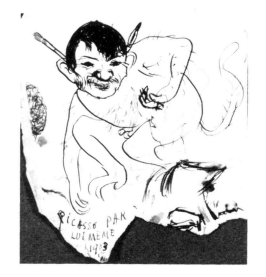

Great Modern Masters

Picasso

General Editor: José Maria Faerna

Translated from the Spanish by Wayne Finke

ABRAMS/CAMEO

HARRY N. ABRAMS, INC., PUBLISHERS

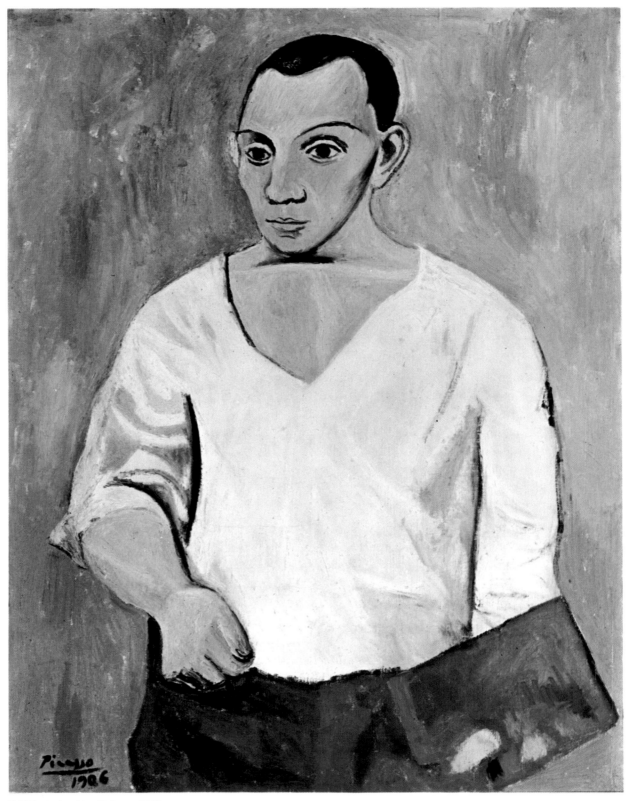

Self-Portrait with a Palette, *1906*.
Oil on canvas, 36¼ × 28¾″ (92 × 73 cm).
The Philadelphia Museum of Art, A. E. Gallatin Collection

Pablo Picasso and Cubism

No one disputes the fact that Pablo Picasso is among the most important masters of the twentieth century, a reputation bestowed upon him as early as the 1920s, when Cubism was already well known. In his life and work he personifies perfectly the image of the modern artist: he chose the Bohemian lifestyle at the beginning of the century, having scorned the certainty of a conventional and academic career for which he demonstrated himself to be perfectly qualified; he possessed overwhelming and almost mythic vitality, symbolized in the figure of the minotaur ever present in his work; and he had exceptional natural talent that lends to his paintings that sense of ease expressed in the famous words: "I do not seek, I find."

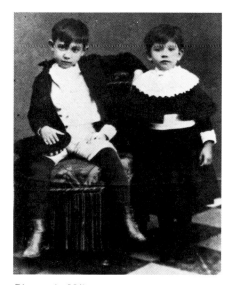

Picasso in Málaga, approximately seven years old, in the company of his sister Lola. Shortly after this photograph was taken he began to draw, and those first drawings indicate an orientation toward painting early in his life.

Breaking New Ground

But Picasso's work would not occupy the place it does today unless one adds to those qualities his determination to break new ground on the path that modern painting had been exploring since the time of Edouard Manet and the Impressionists. The modernist objective—which Picasso made his own—was to find a method of representing reality within the superficial condition of painting which has its own coherent, internal logic. Picasso took the definitive step in achieving this goal in 1907, when he completed *Les Demoiselles d'Avignon*, and thus opened the doors to Cubism.

Cubism is a specifically pictorial revolution that has little to do with the physical or philosophical theories with which critics have at times sought to establish direct relationships. Paul Cézanne had already introduced spatial distortions in his still lifes, seeking to provide the viewer with the maximum information possible about the painted object. To that precedent may be added the profound impression made on Picasso by primitive Iberian sculpture and African masks which revealed modes of synthetic and non-naturalistic representation unknown in the European tradition. Incorporating those lessons in *Les Demoiselles*, the painter from Málaga crossed the threshold between painting things as one sees them and representing what one knows about them. Until World War I, both Picasso and painter Georges Braque explored the possibilities of that new idea, unfolding and juxtaposing different planes and views of the subject on the surface of the canvas.

Hercules with a Club, 1890. 19½ × 12⅝" (49.5 × 32 cm). The artist was not even ten years old when he began this academic study.

A New Order

As a result of that exploration, the Cubist painting generates its own order, independent of the order of reality perceived by the senses. This order extends not only to the objects represented, but to the depiction of the empty space between them. The declaration that the Cubist painter paints an object as though moving around it should not be taken literally. Nor is the artist merely seeking to introduce time as a fourth dimension in the painting. Instead, the painter begins with an idea, a mental image of the object, in order to reproduce it according to strictly pictorial laws. It

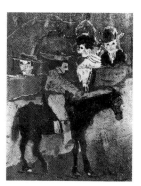

Picador, c. 1889–90. Oil on wood, 9½ × 7½" (24 × 19 cm). The first example of Picasso's preference for bullfighting subjects.

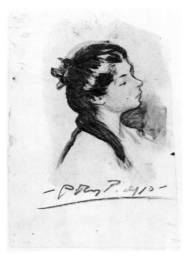

Portrait of Lola, *1899. Sepia on paper, 9 × 6¾" (23.1 × 17 cm). The influence of fin-de-siècle Barcelona can be seen in the elegant ease of technique in this drawing.*

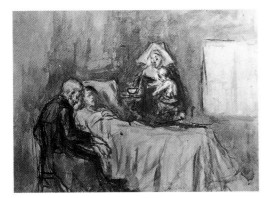

Sketch for "Science and Charity," *1897. Watercolor on paper, 9 × 11¼" (22.8 × 28.6 cm). A preparatory study for his first painting conceived with true professional ambitions.*

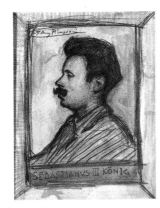

Portrait of Sebastián Junyer-Vidal, *1900. Pencil, colored pencil, and watercolor, 8¼ × 6¼" (21 × 16 cm). This Germanic-style portrait reflects the Wagnerian fashion of the time.*

is futile to attempt to *reconstruct* an object within a Cubist painting as one would compose a solid geometric body in three dimensions based on a two-dimensional diagram. What is indeed possible is to *recognize* it, and for that purpose the painter leaves a series of figurative clues which the viewer can use as a guide.

The Painting as Object

But Cubism will go even farther in its manipulation of the painted object. Its discoveries permit the establishment of a new relationship between painting and reality: what one perceives as a whole can be depicted in its parts; what is seen as concave can be painted in a convex fashion, and vice versa. From 1912 onward, first Picasso and then Braque began to integrate into their works scraps of colored or printed paper, cigarette packages, and other elements from their daily surroundings, inventing what is known as collage and *papier collé*. In this purification of Cubist expression the terms of portrayal are altered: it is no longer necessary to start with the object in order to form the structure of the painting. Rather, beginning with a scheme of drawing and color, representative elements are introduced onto the canvas—whether painted, glued on, or super-imposed—to piece together or synthesize the composition. Thus we reach the mature phase of Cubism, which is commonly called Synthetic Cubism, as opposed to "primitive" Cubism, in which the process can be said to be, on the contrary, analytical, because the object is broken down on the canvas into a composite of parts.

At this point, the painting moves beyond being a representation of real-ity to being an element added to it: what the Cubists called the *tableau-objet* (painting-object). Thus the circle closes, and Cubism, from then on, becomes the matrix of almost all avant-garde expression, somewhat like the basic grammar of an interdisciplinary, formal language, valid in its universal application to the fields of art, design, architecture, and indus-try. Although the development of Cubism is an honor Picasso shares with Georges Braque and, to a lesser degree, with Juan Gris and other painters and theoreticians of the movement, after 1907 the key steps were always taken by Picasso, which partly justifies his reputation as the first truly modern painter.

A Universal Art

Although Cubism is the cornerstone of Picasso's art, his career tran-scends that of any "school." It is often said that his artistic evolution sum-marizes all the trends of modern art. This statement is only partially true, but it gives some idea of his capacity to interpret and convey the spirit of his time; the universal and emblematic value of *Guernica* as an expres-sion of the horror of war speaks for itself. Picasso's sphere of influence is vast and informs our understanding of both the historical avant-garde and abstract painting after 1945. Over time, his discoveries were appropriated by him and by others in contexts quite different from their original appli-cations. This explains why he may be the pivotal figure of twentieth-century painting, and likewise suggests why his work—even the late, marginal, or seemingly minor—forever retains an artistic vitality that few can claim for themselves.

Pablo Picasso/1881–1973

Pablo Ruiz Picasso, who once his career as a painter was established would sign only with his mother's surname, was born in Málaga, Spain, into an artistic family. His father, José Ruiz Blasco, earned his living as a drawing teacher, first in Málaga and then in La Coruña and Barcelona. Although Picasso began his studies of the fine arts in La Coruña, it was in Barcelona, where the family moved in 1895, that he completed his formal training and began his career. His extraordinary artistic talents were soon apparent, and the prize of honorable mention he won for his work *Science and Charity* at a national exhibition in 1897 seemed to augur for him a brilliant future as an academic painter.

The Bohemian Years

Instead of following the path of academic painting, however, Picasso immersed himself in the Bohemian life of Barcelona at the beginning of the century. At that time the Catalonian capital was an artistic center of great vitality, where modernism in architecture and the decorative arts coexisted with the major trends of the European art scene: the poetic taste for Symbolism, embodied in painters like Modest Urgell, and the new, *plein air* painting that Ramón Casas and Santiago Rusiñol had imported from Paris. Picasso frequented Els Quatre Gats tavern, where he met all the Catalan artists of the day. In 1900 he made his first trip to Paris with his friend Carlos Casagemas. One year later, he celebrated his first French exhibition, and in 1904 he took up residence in the legendary Bateau-Lavoir in the district of Montmartre. He spent this stage of his career—the so-called Blue and Rose Periods which lasted until 1906—traveling between Paris and Barcelona. In the paintings of this era the figures, drawn with the mastery for which Picasso is well known, stand out against monochromatic backgrounds formed from hues of blue and rose. Predominant in this period of Picasso's work is the influence of the Catalan painter Isidro Nonell, with his preference for allegorical scenes of the most desolate and sorrowful aspects of human existence.

Cubism

An interest in Iberian sculpture and the African masks in the Musée du Trocadéro marks a new direction in Picasso's work of 1906 (*Self-Portrait with a Palette, Portrait of Gertrude Stein*). During that year and the next the artist worked on *Les Demoiselles d'Avignon*, truly the point of departure for Cubism. In the paintings completed in 1908 in Horta de Ebro, geometric and faceted volumes are spread across the surface of the canvas, signaling the fundamental steps in the new movement. The development of this movement took place between 1909 and 1914, the period when Picasso worked closely with Georges Braque, until that moment an adherent of Fauvism, whom he met in 1907 through the poet Guillaume Apollinaire. That collaboration purified this new language and produced new modes of expression such as collage and *papier collé*, which Picasso began to employ about 1912. The emergence of these new techniques

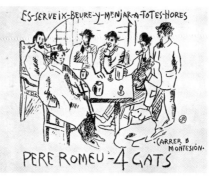

Picasso included a self-portrait in this drawing for the Barcelona tavern Els Quatre Gats in 1902, in the company of Pere Romeu (proprietor of the establishment), Josep Rocarol, Emili Fontbona, Angel Fernández de Soto, and Jaime Sabartés.

Beginning with the large Self-Portrait of 1901 (see fig. 15), Picasso frequently prepared self-portraits. This sketch was made in Paris, a year after the famous 1901 painting with which it bears a relationship.

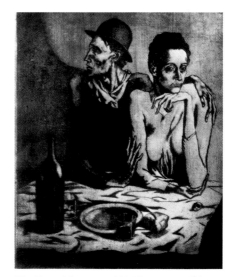

The Frugal Repast, *1904. Etching, 18³/₁₆ × 14¹³/₁₆" (46.5 × 37.6 cm). This is one of the artist's first attempts in the field of engraving.*

Man with Sheep, *1944.*
Bronze, 86⅝ × 30¾ ×
28⅜" (220 × 78 ×
72 cm). Picasso's
sculptures are
considered among the
greatest creations in this
discipline of the
twentieth century.

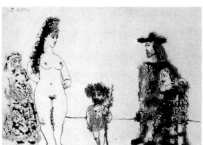

Plate III from 347 Series, *1968. Aquatint,*
9¼ × 13⅛" (23.5 × 33.4 cm). During
his later years Picasso frequently treated
mythological themes, evoking the great
masters of the past.

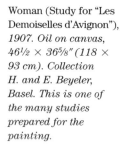

Woman (Study for "Les
Demoiselles d'Avignon"),
1907. Oil on canvas,
46½ × 36⅝" (118 ×
93 cm). Collection
H. and E. Beyeler,
Basel. This is one of
the many studies
prepared for the
painting.

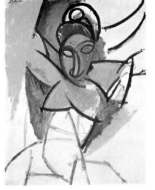

established a new relationship between the painting and perceived reality, constituting a pivotal moment in modern painting.

In the further refinement of the new artistic method that is commonly known as Synthetic Cubism, the collaboration between Picasso and Serge Diaghilev's Ballets Russes holds great importance. In 1916, through his connection with Jean Cocteau, Picasso designed the sets for the ballet *Parade*, which had a scenario by Cocteau and music by Erik Satie; this served as the inspiration for a certain decorative dimension of Cubism. During that period Picasso met ballerina Olga Koklova, whom he married in 1918 and who was the mother of his first son. The painter previously had relationships with Fernande Olivier and Marcelle Humbert, the Eva in the first Cubist canvases.

A Century of Wars

During the period between the two World Wars, Picasso continued to explore the possibilities of Cubism through painting, collage, and sculpture, eventually returning to a classical, Mediterranean figurative style (*Three Women at the Spring*, 1921). The introduction of fantastic subjects captured the attention of the Surrealists, who had great respect for the figurative tradition. The Spanish Civil War marked a milestone in the artist's life and work; Picasso embraced the Republican cause and accepted the position of Director of the Prado Museum in Madrid. From this position he was able to contribute to safeguarding Spain's national artistic treasures. In 1937, German Nazi planes, aided by rebel forces under General Francisco Franco, bombed the town of Guernica, resulting in the genocide of a civilian population. Picasso's profound shock and horror provoked by this act of slaughter was translated into *Guernica*, which was shown in the Spanish Pavilion of the Paris World's Fair in that same year. In time it became the most famous and most reproduced painting of the twentieth century. The influence of *Guernica* lends a certain expressionism to all of the artist's work of the 1930s, adding a new dimension to the Cubist treatment of the human figure. These were the years of Picasso's relationship with Dora Maar, who followed Marie-Thérèse Walter, the mother of Picasso's second child.

The Final Years

Following World War II Picasso took up residence in the south of France, an area which he had frequented since the 1920s. He devoted more of his energy to the mediums of ceramics and sculpture which he practiced continuously throughout his career, to the point that he is considered one of the great sculptors of the century. His abundant output of graphic art also deserves, on its own merits, a privileged place in the history of modern art. Picasso's last two amorous relationships, with Françoise Gilot (with whom he had two more children) and Jacqueline Roque (whom he married in 1961 and with whom he remained until his death), provided him with the stability that made the astonishing productivity of his later career possible. In the later years, the artist employed all the resources he had discovered over his long career to create a body of work that displays an extraordinary freedom, filtering through it, indirectly, aspects of his personal life. Picasso's legendary Dionysian vitality lasted until he died in 1973, while still at the height of his creative powers.

Plates

A Precocious Mastery

From his earliest artistic studies, Picasso revealed extraordinary technical talent, no doubt nurtured by his father, a painter and drawing teacher. While living in La Coruña between 1891 and 1895, the future artist began to take classes in the fine arts, studies that he continued at the School of Fine Arts (known as La Lonja) in Barcelona. From those early years there exist several works in a naturalistic, academic style that attest to Picasso's virtuosity in adolescence. Portraits, some landscapes, and social themes of a compassionate nature—which reappear in the Blue Period—are the typical genres during this period. The influence of Muñoz Degrain, a nineteenth-century painter highly esteemed by Picasso's father, is perhaps the most evident. The prize of honorable mention for the young artist's work *Science and Charity*, awarded at the National Exhibition of Fine Arts in 1897, closes this chapter of Picasso's development as an academic painter. What would have been an excellent beginning career for a conventional painter of the period was for Picasso the last stage before pursuing new paths.

1 The Farm at Quiquet, *1898. Painted one year after* Science and Charity, *this work reflects a different, happier spirit, far from the dark palette characteristic of academic painting.*

2 The Sick Woman, *1894. The illness that caused the death of Picasso's sister Concepción appears to have signaled a dark period for Picasso, one bathed in death and grief. This small canvas, painted when he was still in La Coruña, foreshadows the compassionate treatment of the subject matter that culminated three years later in* Science and Charity.

3 Science and Charity, *1897. Science is personified by the doctor taking the pulse of the patient, whose hand already reveals the ashen tint of death. Charity is personified by a nun who tends to the child as she offers a drink to the dying woman. Picasso began and ended his career in academic painting with this canvas, for which his father and his sister Lola posed, and which reveals an unusual expertise for a sixteen-year-old adolescent.*

1

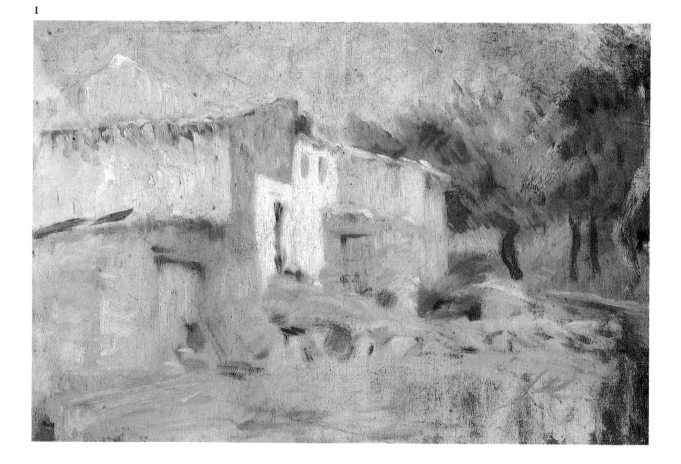

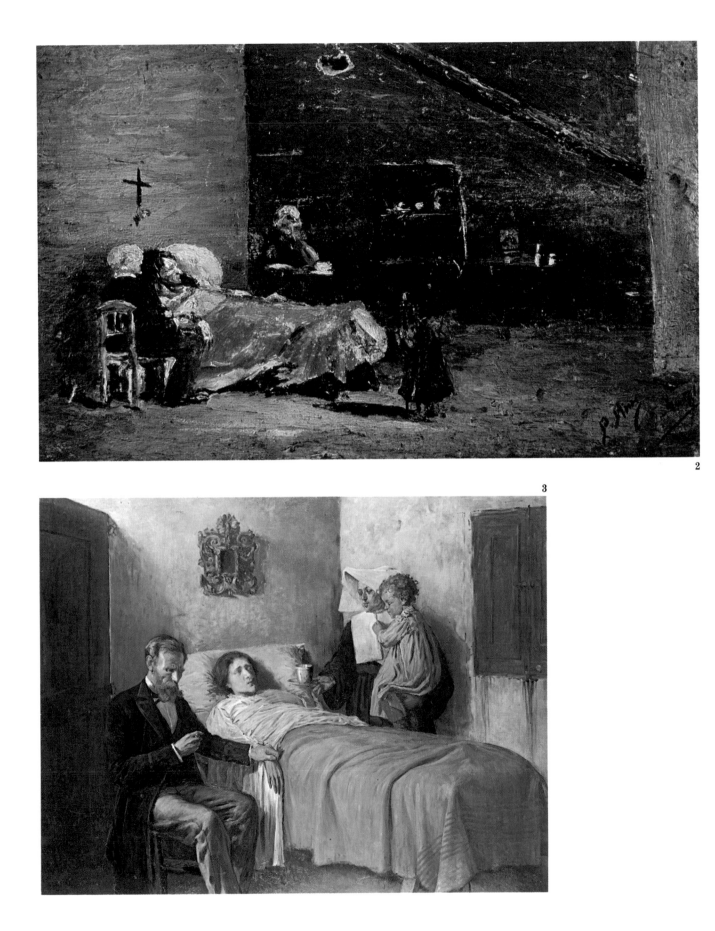

Barcelona, Fin-de-siècle

Picasso had his first studio at No. 4 Calle de la Plata, in Barcelona. The multiple stimuli offered to him by this cosmopolitan city, at that time well entrenched in contemporary European artistic currents, soon led him to a Bohemian lifestyle that he shared with other young artists. He would meet with his first circle of friends—among them Carlos Casagemas, Manuel Pallarès, and Sebastián Junyer-Vidal—at Els Quatre Gats tavern. There he met the most important Catalan artists of the time, such as Isidro Nonell, Joaquim Mir, Julio González, and Ramón Pitxot, and it was also there, in 1900, that he held the first exhibition of his works. Until the end of the first decade of the century Picasso maintained strong ties to Barcelona, although beginning in 1904 he was already residing in Paris on a steady basis. Before venturing in his decidedly personal, creative direction, Picasso experimented with almost all the stylistic modes offered by the art of his time, from Post-Impressionism and Symbolism to the genre of café and brothel scenes in the style of Edgar Degas or Henri de Toulouse-Lautrec.

4

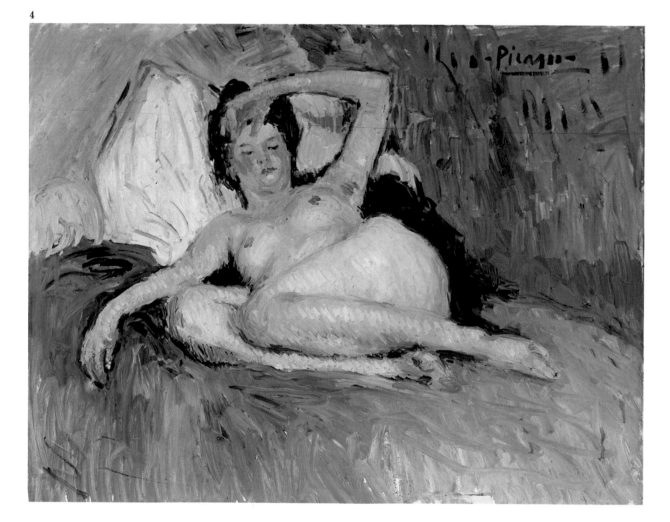

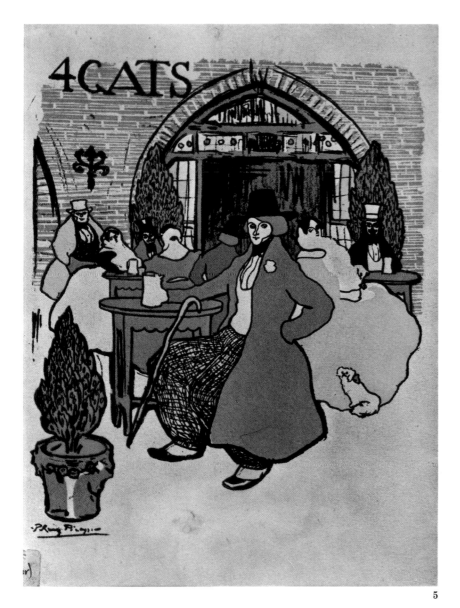

4 Female Nude, *1901. A harmonic blend of blue, yellow, and green serves as a background for this nude, painted in Paris, but similar in style to that of the painters who dominated the Catalonian artistic scene in those first years of the new century.*

5 Poster for the Menu of Els Quatre Gats, *1900. Pere Romeu, manager of the establishment that best represents the painter's Barcelona period, commissioned this work, which follows the style of modernist poster art predominant in that era.*

6, 7 Sabartés, "Decadent Poet," *1900.* The Manola (Inspired by Lola Ruiz Picasso), *1900. The subjects—Picasso's friend Sabartés and his sister Lola—belonged to the immediate circle of the painter. The Symbolist treatment of these figures corresponds to the cultural fashion of the time. Both canvases formed part of the exhibition in 1900 at Els Quatre Gats.*

5

6

7

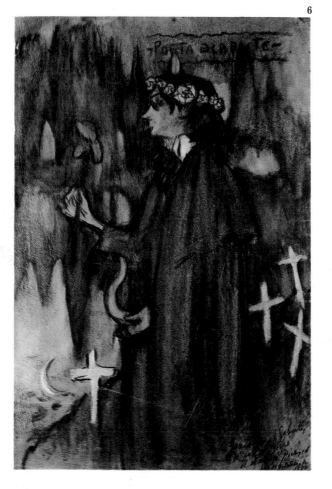

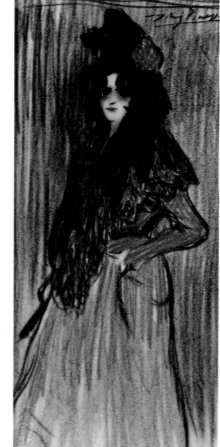

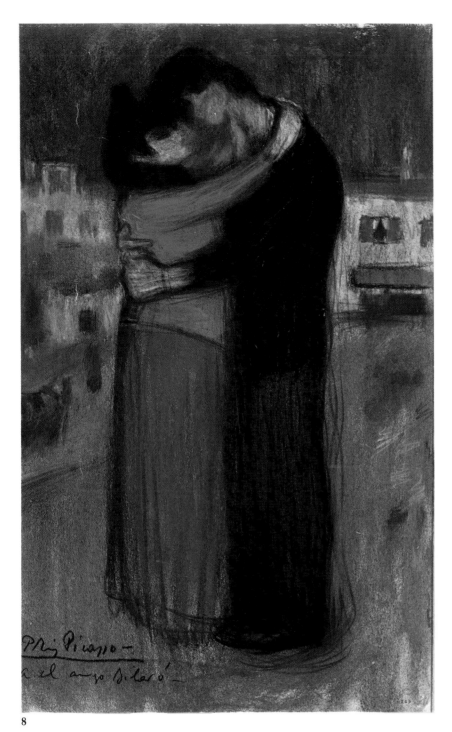

8

9

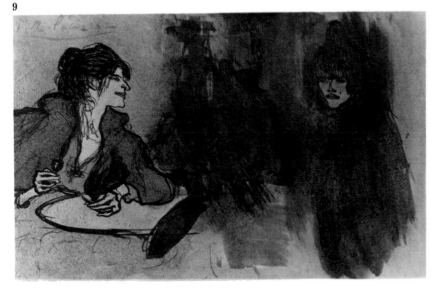

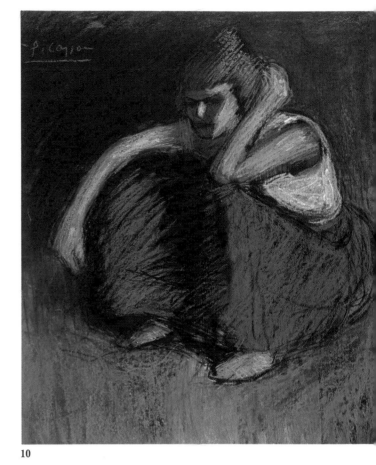

10

8 Street Embrace, *1900. The firmness of the pictorial gesture, the rotundity of the figures, and the somber atmosphere of the scene clearly evoke the influence of Isidro Nonell, in whose Paris studio Picasso and Carlos Casagemas stayed during their trip that same year.*

9 Two Female Figures, *1900. The fluidity of the drawing and the depiction of Bohemian life and nighttime revelry recall Edgar Degas and Henri de Toulouse-Lautrec, both especially fond of this type of rapid exercise in watercolor.*

10 The Red Skirt, *1901. This pastel likewise recalls Toulouse-Lautrec and Degas, but with a greater chromatic violence and, above all, an interest in the mass of the figure.*

11, 12 Bullfight Scene, *1901.* Bullfighters and Bull in Anticipation, *1900. Picasso, a devoted fan of the bullfight, painted several bullfighting scenes in the early part of his career. He would not return to the subject matter until many years later, when it became a vehicle for his personal mythology.*

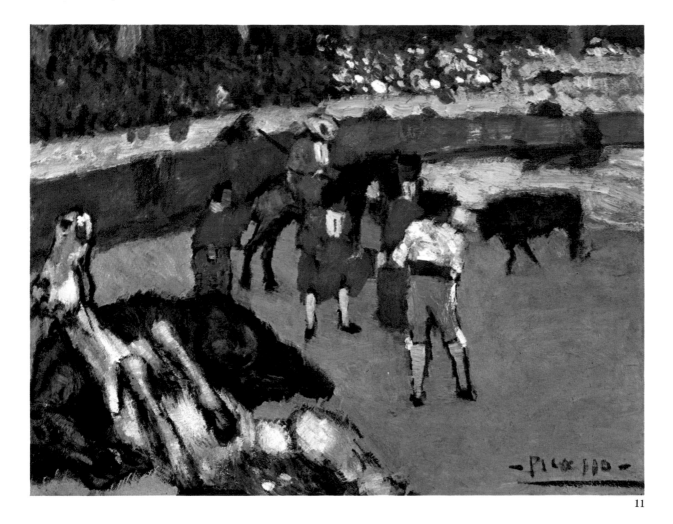

11

12

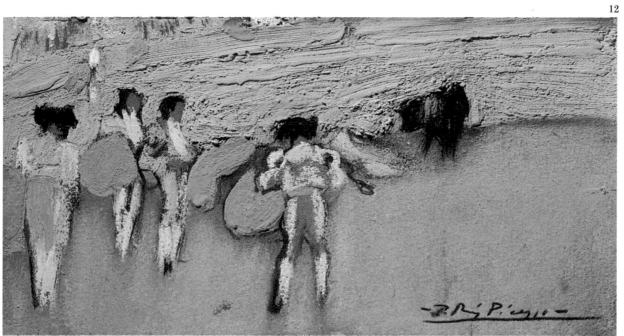

Blue and Rose Periods

Between 1900 and 1906, coinciding with his initial immersion in the French artistic scene, Picasso began the first phase of his career to bear a personal stamp. The influence of modernist Barcelona is still apparent in some of the canvases of this period, revealing a decadent, Symbolist inspiration in harmony with fin-de-siècle taste. Figures of monumental size stand out against monochrome backgrounds in which the color blue or rose predominates, thus giving a label to the work of these years. It is difficult to establish a division between the Blue Period and the Rose Period, although in the former moody and melancholic subject matter is more in evidence: poverty-stricken men and women, mothers and children cast in apparent misery and suffering, and allegorical figures of human sadness all populate these canvases. In them one can perceive the influence of Isidro Nonell and El Greco, whose painting enjoyed a revival of popularity at the beginning of this century. In the Rose Period, however, there is a frequent appearance of performers and circus figures, characters the Montmartre painters were very fond of depicting. Still quite young, Picasso had freely developed a personal aesthetic with which his work could be identified, and yet he soon abandoned it in order to leap into the unknown.

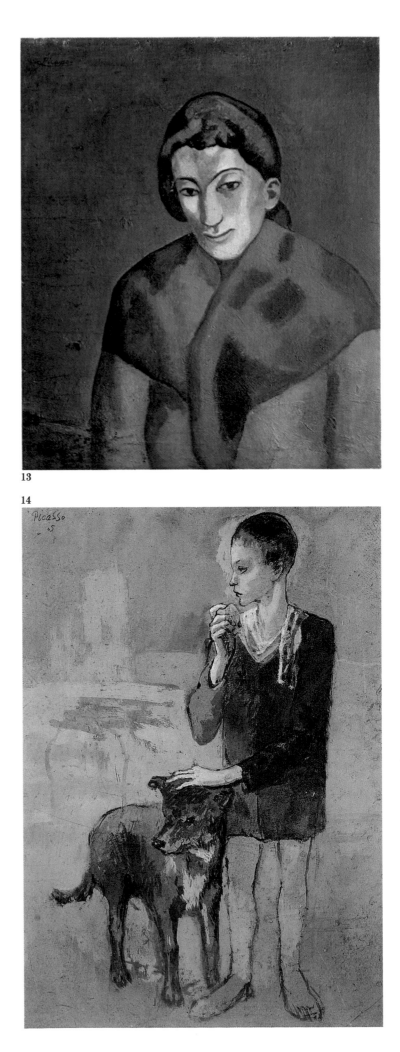

13

14

13 Woman with a Scarf, *1902. One of the first examples of the so-called Blue Period; nonetheless the work reveals a flatness and planarity in the depiction of the figure, foreshadowing the paintings that gave rise to Cubism four years later.*

14 Boy with Dog, *1905. The flat, linear treatment of the subject bears witness to the influence of Catalonian modernism.*

15 Self-Portrait, *1901. Realized with a great economy of means, this is one of many self-portraits that the painter would complete throughout his career. The traits of depression and premature aging, surprising in a man barely twenty, reflect the melancholy and pessimism associated with fin-de-siècle culture.*

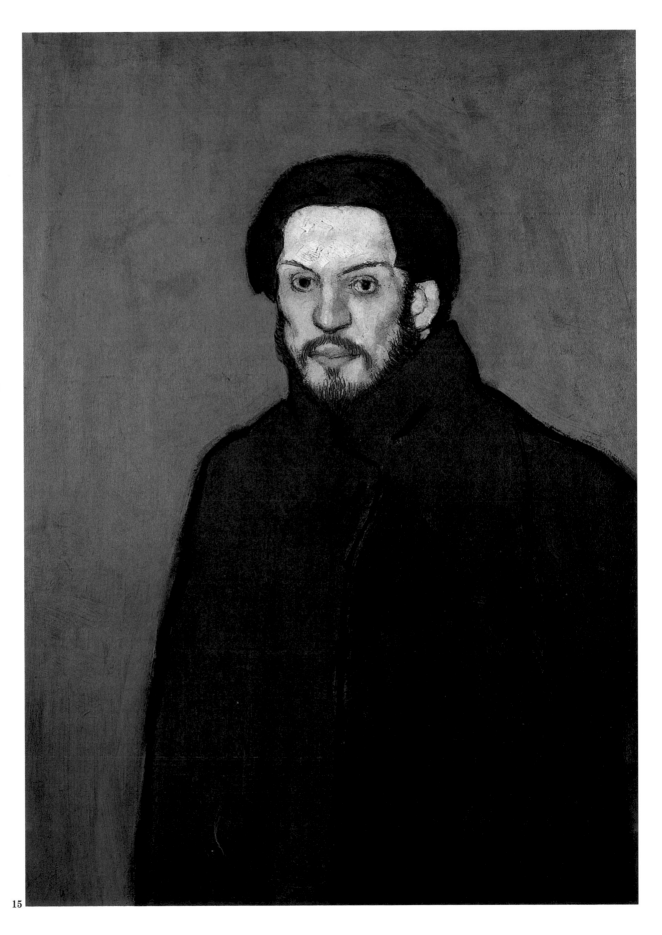

15

16 Maternity Beside the Sea, *1902. The allegory implicit in the subject is characteristic of fin-de-siècle Symbolism, a movement that was firmly rooted in Barcelona in those years.*

17 La Vie, *1903. This large-scale allegory was the most ambitious canvas undertaken by Picasso until that time. Conceived as a group of symbolic figures with open-ended significance, it comprises an homage to his friend Carlos Casagemas—the male seminude figure—who had committed suicide in Paris the previous year, following a failed romance.*

16

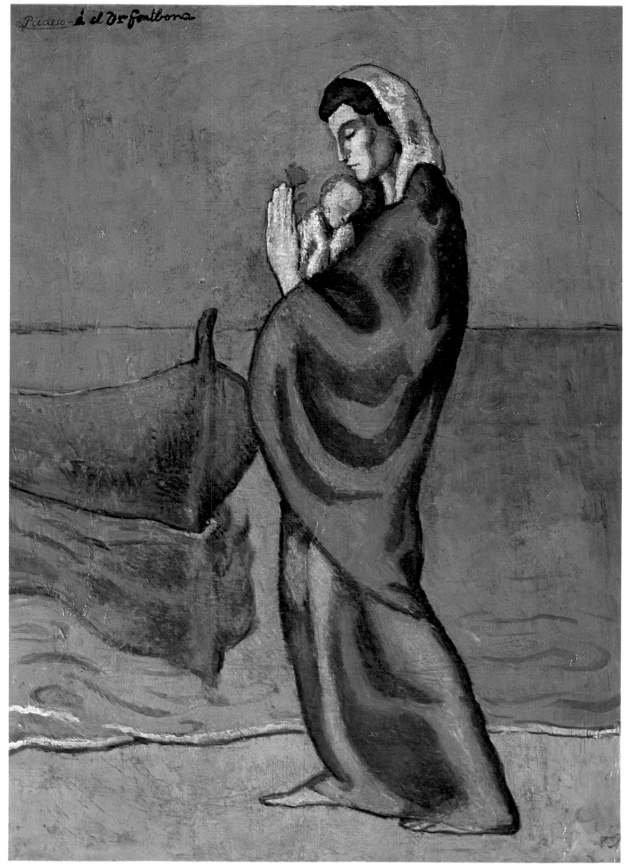

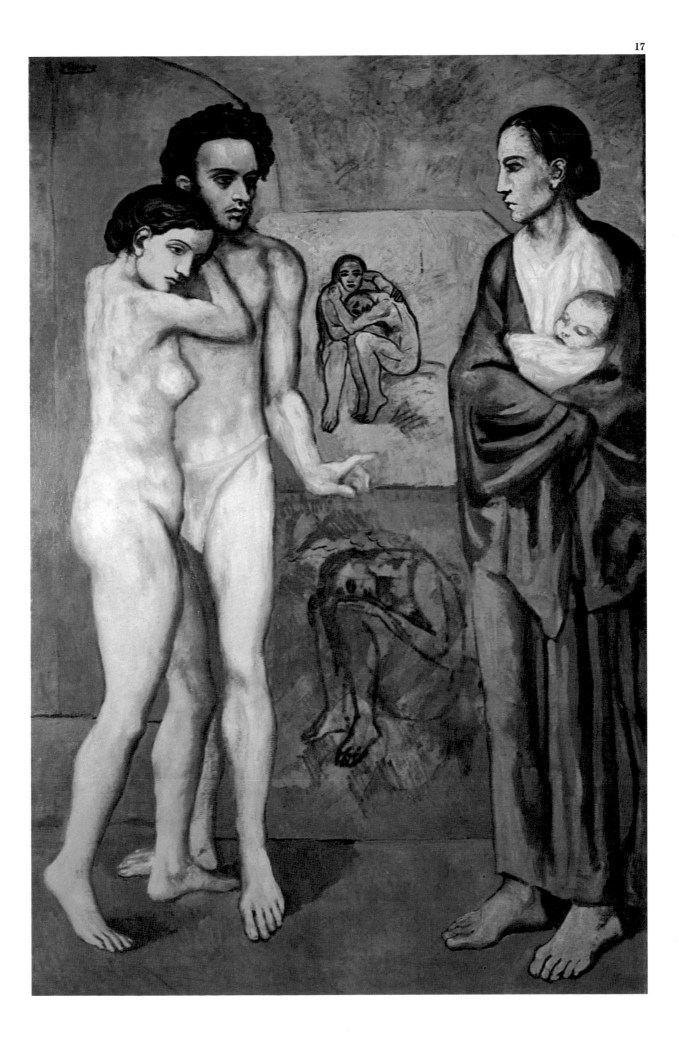

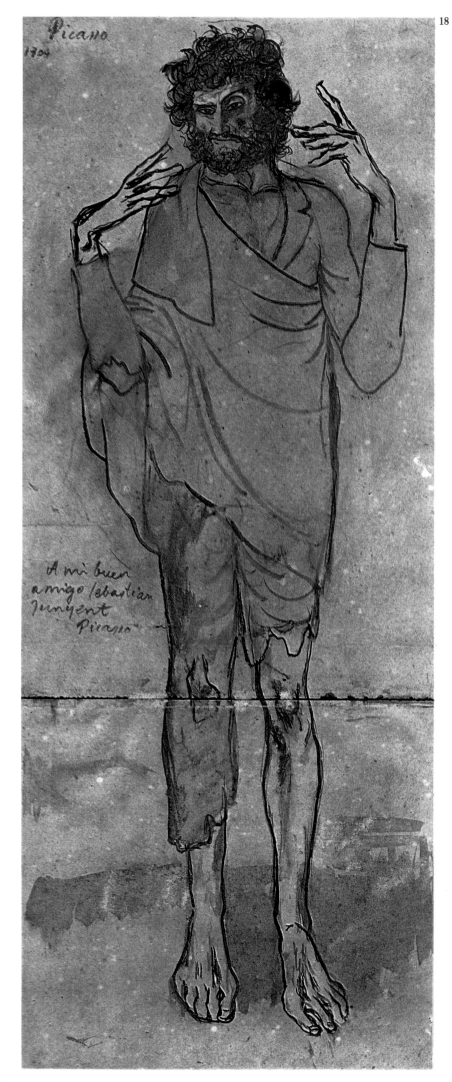

18 The Madman, *1904. Like many canvases of the period, this small watercolor on wrapping paper is dedicated to Picasso's friend Sebastián Junyer-Vidal and reveals the command of drawing of which Picasso was always proud.*

19, 20 Couple with Child at the Café, *1903.* Casagemas Nude, *1904. From the Bohemian years in Barcelona and Paris at the beginning of the century there still exist many of these small drawings that share the desolate quality of Picasso's contemporaneous paintings.*

21 Meditation (Contemplation), *1904. One of the first paintings Picasso completed in Paris after taking up residence at the Bateau-Lavoir in Montmartre. Despite the warm atmosphere of the ochre and reddish tones, this studio scene, which includes a self-portrait, does not completely abandon the pathos of Picasso's works of those years.*

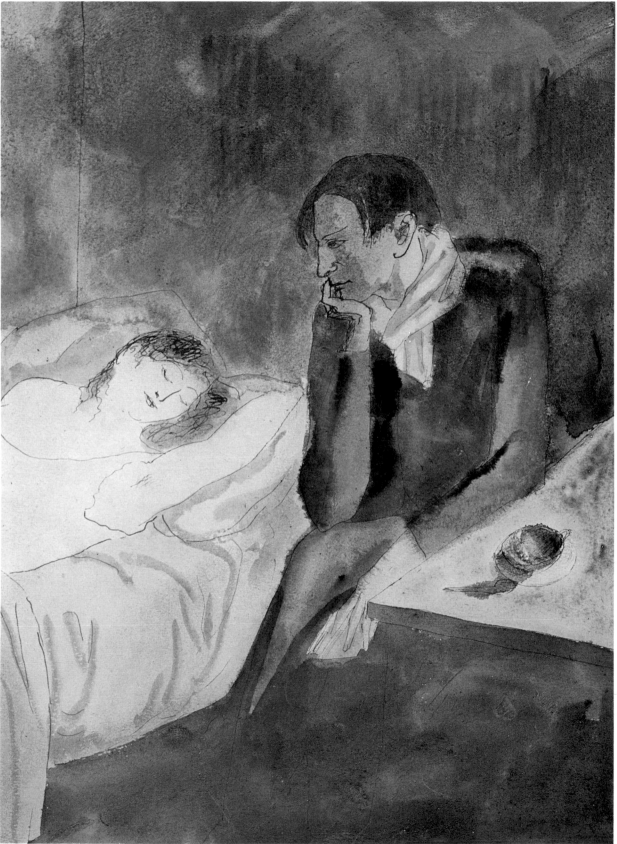

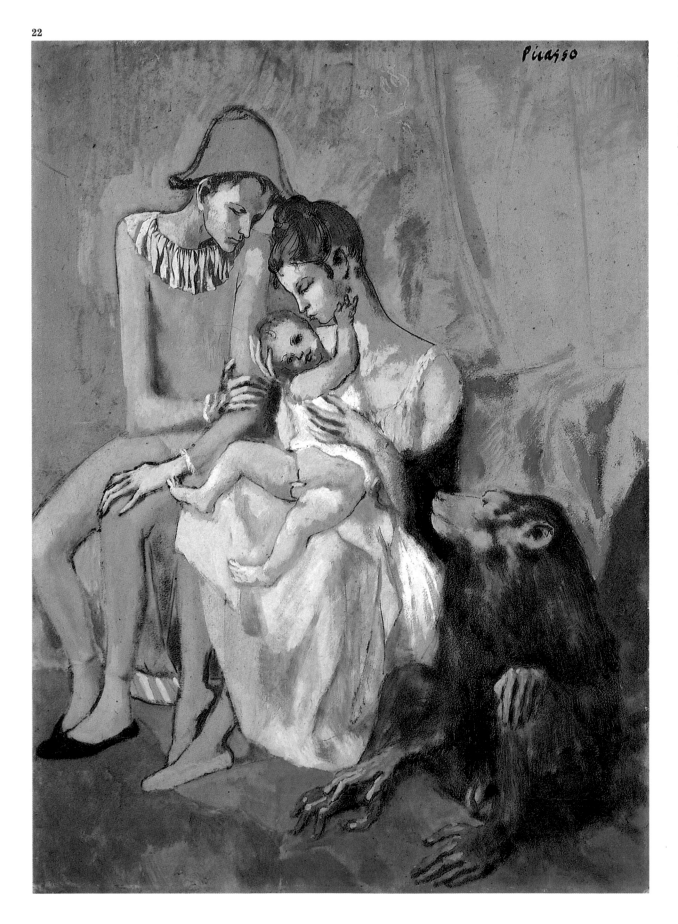

Picasso

22 The Acrobat's Family with a Monkey, *1905. A backstage circus scene characteristic of the so-called Rose Period. The placement of the figures in a plane that is near but oblique to that of the canvas is a typical device of painters such as Edgar Degas and Edouard Manet, who so interested Picasso in that period. The shallow treatment in the depiction of space avoids illusionistic excess.*

23 Acrobat on a Ball, *1905. This is one of the first canvases in which one clearly perceives Picasso's interest in the portrayal of mass. While the balancer has the flat, decorative planarity of Picasso's figures of that period, the large figure in the foreground is modeled with a marked chiaroscuro technique.*

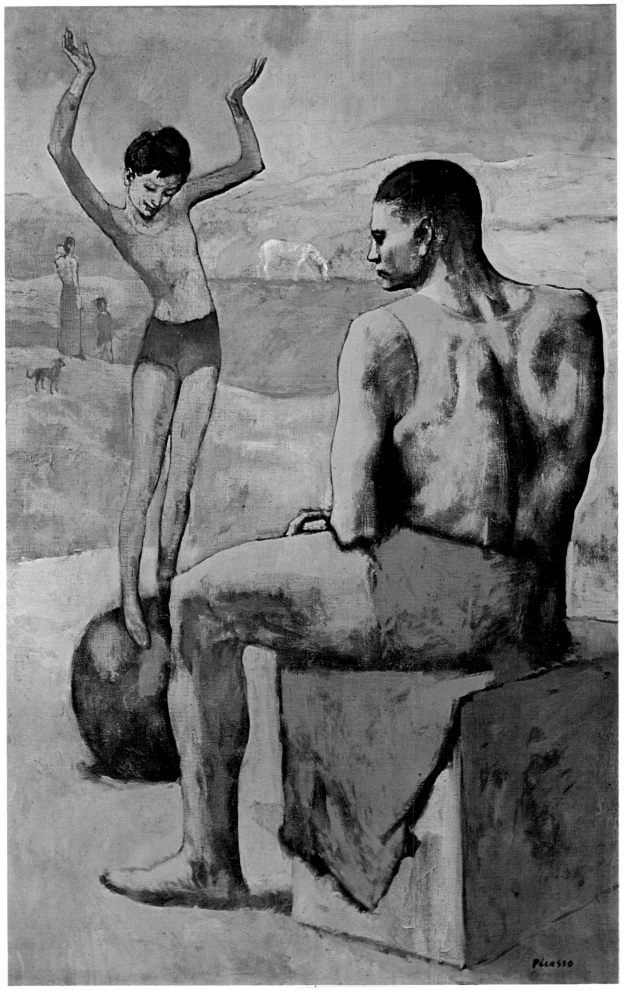

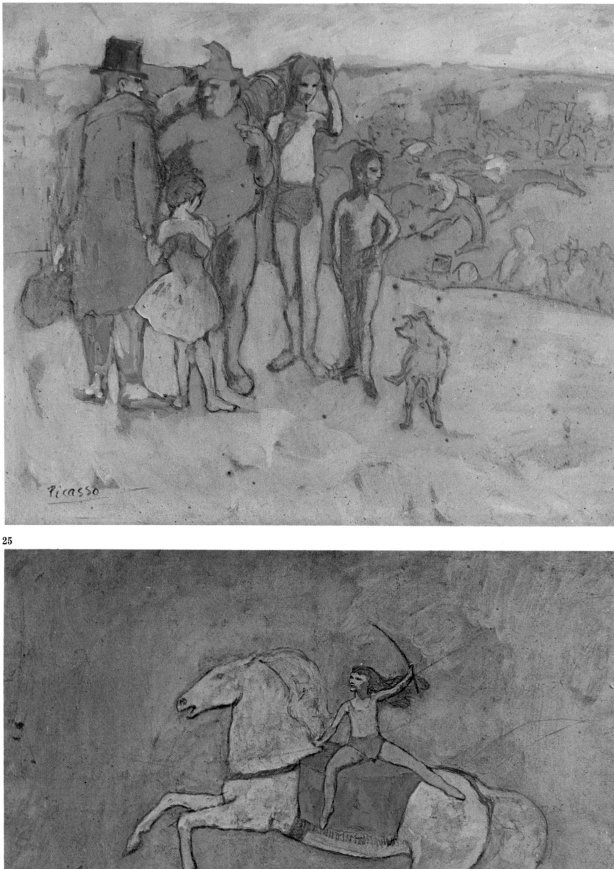

24, 25 Family of
Acrobats, *1905.* Amazon
on Horseback, *1905.*
*Circus performers often
appear in
the work of the
Montmartre painters of
the period who
empathized with the
subjects' marginal
place in society and
were attracted to the
pictorial possibilities
they offered.*

26 La Toilette, *1906.*
*Picasso painted this
canvas in Gosol, located
in the Pyrenees near
the city of Lérida. It
represents one of the
last works faithful to
the fin-de-siècle style.
That same autumn
the painter would begin
studies for* Les
Demoiselles d'Avignon.

Picasso

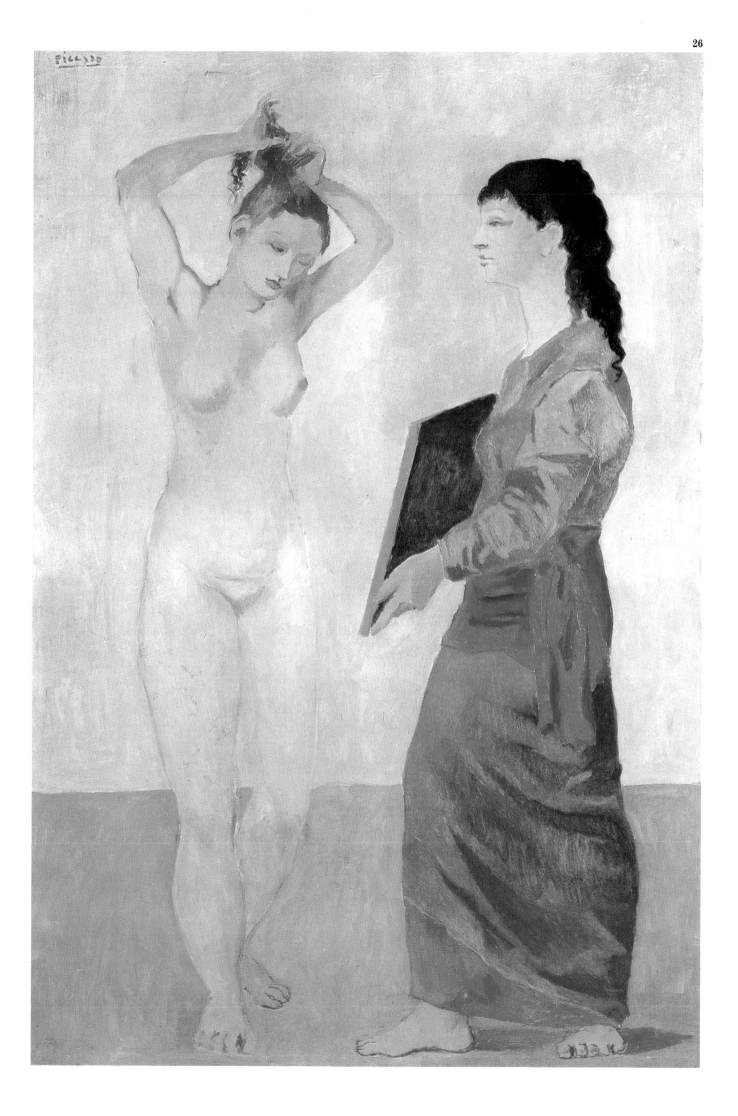

The Threshold of Cubism

Already in some canvases of the so-called Rose Period, Picasso had shown interest in expressing the solidity of masses through the constructive quality of the brushstroke. The presence of the paintings of Paul Cézanne as the inspiration for that method is quite apparent. By adding another important influence, the non-imitative representation of the reality that Picasso found in Iberian sculpture, and particularly in the African statues and masks exhibited in the Musée du Trocadéro, one has all the elements necessary to understand the transformation of his work in 1906, which culminated the following year in the famous painting *Les Demoiselles d'Avignon*. Picasso had not tackled such a large format previously. Preparatory studies document the creative process behind this important work, which was first conceived in a much more naturalistic manner. Also revealed in the studies was the inclusion of two dressed male figures, which would have placed the work within the genre of brothel scenes, although the figures were finally painted out of the canvas. This revolutionary painting displaced Henri Matisse's work *Le bonheur de vivre* as the privileged topic of discussion at Gertrude Stein's regular soirées, which served as the favorite salon of the Parisian literary and artistic avant-garde of the time. Picasso's painting caused a profound impression on all those who viewed it, conscious as they were that the future path of modern painting was prefigured in its subject matter and style.

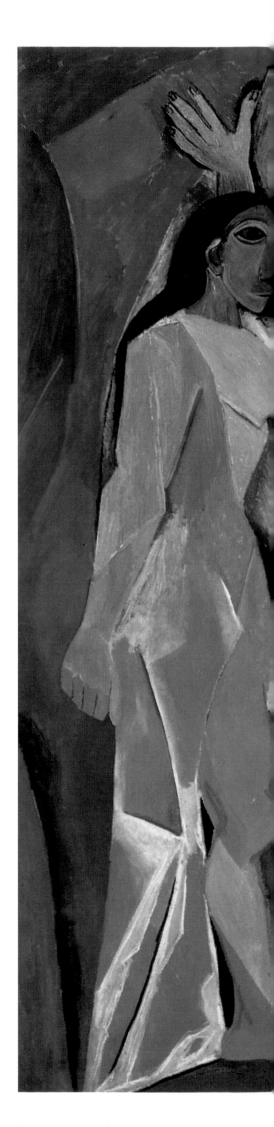

27 Les Demoiselles d'Avignon, *1907. The influence of Paul Cézanne's* Bathers *is evident in the three women at the left, although the forms have been simplified and the noses on the forward-facing countenances are depicted in profile. The two women on the right and the still life, however, signal the first manifestation of Cubism: the heads are portrayed with images of African masks, and the bodies are faceted in juxtaposed planes, united with the surrounding space by a similarity in treatment.*

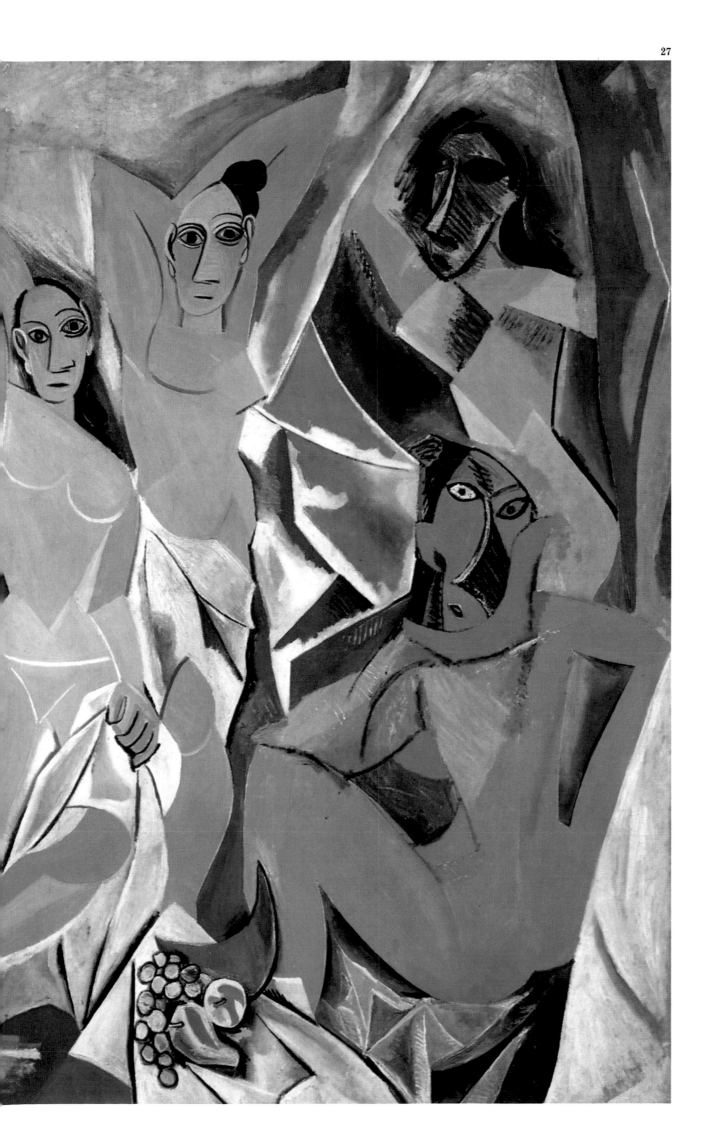

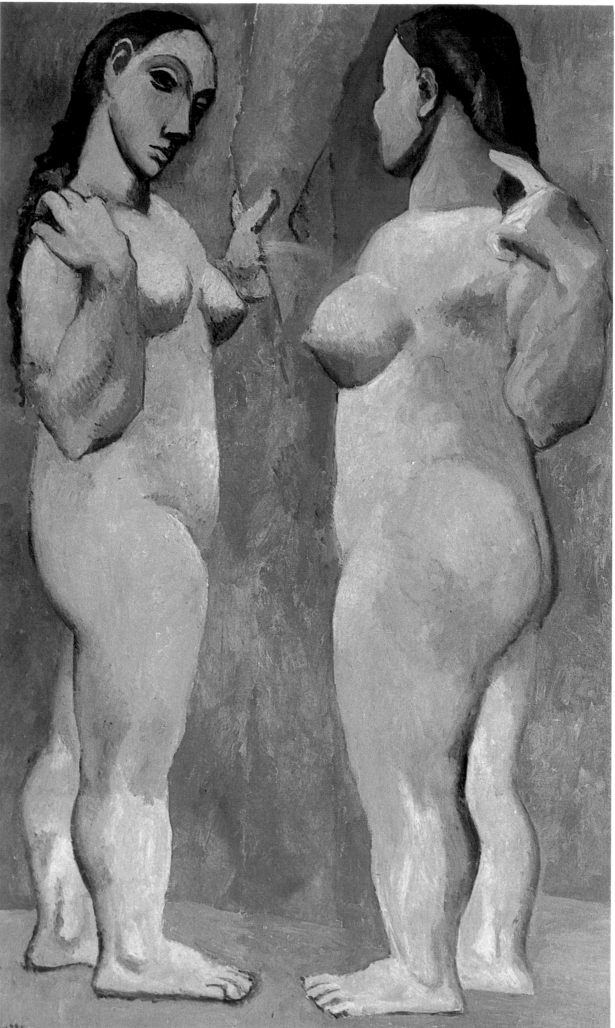

28 Two Nudes, *1906. The earth tones are related to the work of the Rose Period; however, Picasso stressed the almost sculptural mass of the figures, revealing the inspiration of Iberian art during those years. Also suggested by the solidity of the figures is the artist's growing interest in the painting of Paul Cézanne.*

29 Portrait of Gertrude Stein, *1905–06. Although this was one of the few times that Picasso painted a portrait with the model present, in the end his tendency toward experimentation took precedence. The sitter's face is stylized and masklike, and the mass of her body is ambiguously placed within the space, foreshadowing the compositional complexity of* Les Demoiselles d'Avignon *one year later.*

29

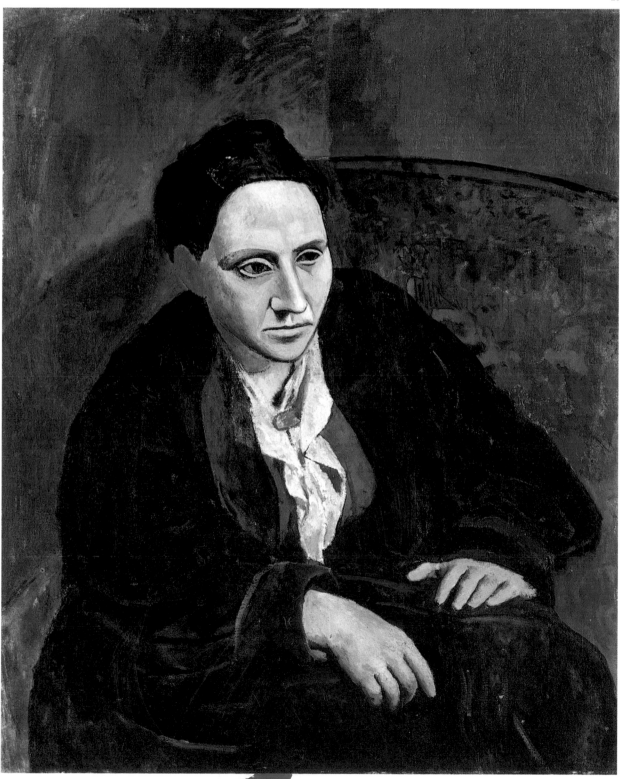

Analytical Cubism

The formative stage of Cubism is almost a private affair between Georges Braque and Picasso. Only a small group of friends—nearly all of them writers—such as Guillaume Apollinaire, André Salmon, Max Jacob and D.-H. Kahnweiler (whose support as a patron was fundamental to this venture) had access to it, for until 1919 neither protagonist held an individual exhibition. Working "like two mountaineers on the same rope," in Braque's words, they labored intensely to formulate the principles of this new mode of painting. Picasso's paintings until 1909 continue to reveal a concern for form, and for the profiling and regularizing of masses, as can be seen in the works he painted that summer in Horta de Ebro (now Horta de San Juan). Over the next two years his fundamental concern was to integrate the volumes and space of the painting into a single scheme of faceted planes, modulating the pictorial surface as though it were a bas-relief. Following the lesson of Paul Cézanne, the brushstroke acquires primarily a constructive value; hence Picasso's renunciation in this period of the use of color, which contributes to the paintings' possessing that character of hermetic grisailles.

30 Landscape with Two Figures, *1908. In some of his canvases of 1907 and 1908, after* Les Demoiselles d'Avignon, *Picasso began to produce integrated, non-illusionistic space, as shown in this landscape. The figures are barely distinguishable from the landscape surrounding them.*

31 The Reservoir, Horta de Ebro, *1909. The first paintings completed at Horta de Ebro in the summer of 1909 gave origin to the name of the Cubist movement, because of the rigorous application of the methods of geometry to the forms. The direction of the brushstroke and the relationship of hues to each other reinforce that constructive, or tectonic sense of color that the Cubists took from Paul Cézanne. Here, the planes seem to interlock, but the background still possesses a distinguishable treatment.*

30

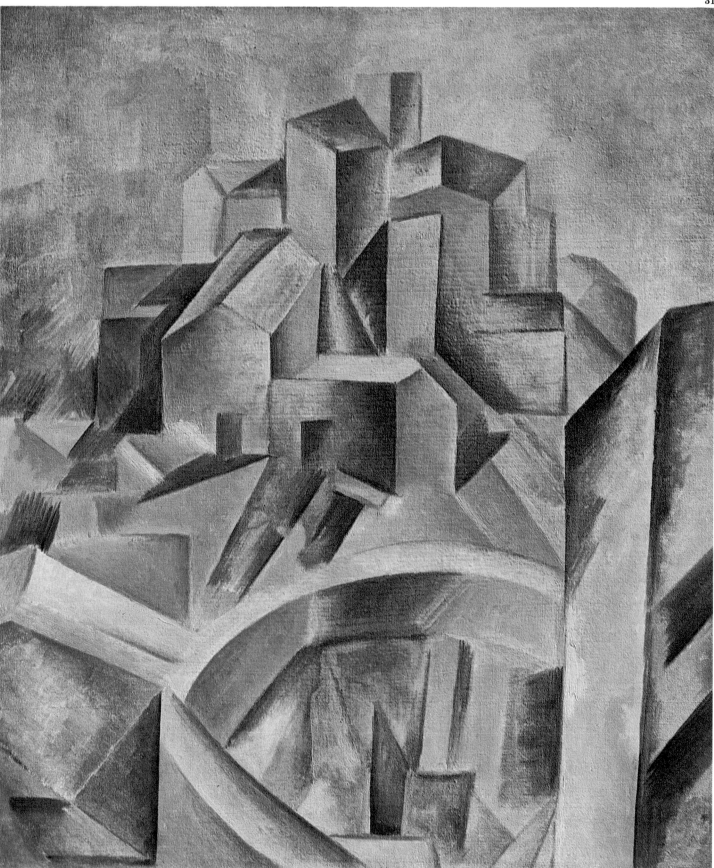

32 Bread and Fruit Dish on a Table, *1909. Picasso painted this still life in the winter, in Paris, prior to his sojourn in Horta, but it confronts some of the same issues as the canvases completed later in the year. The complex representation of the table in various planes and the curtain's geometric folds are precursors to the Cubist pictorial schemes of the following years.*

33 Girl with a Mandolin, *1910. The subject matter of this painting is fully within the Cubist repertory, but the new mode of expression is still tentative. There is a tension between the lower part of the canvas, which is still quite illusionistic in its depiction of the girl, and the upper part, where there is more abstraction in the juxtaposition of planes on the surface. The lack of definitive borders is one of the problems that would be most difficult for Cubism to resolve.*

32

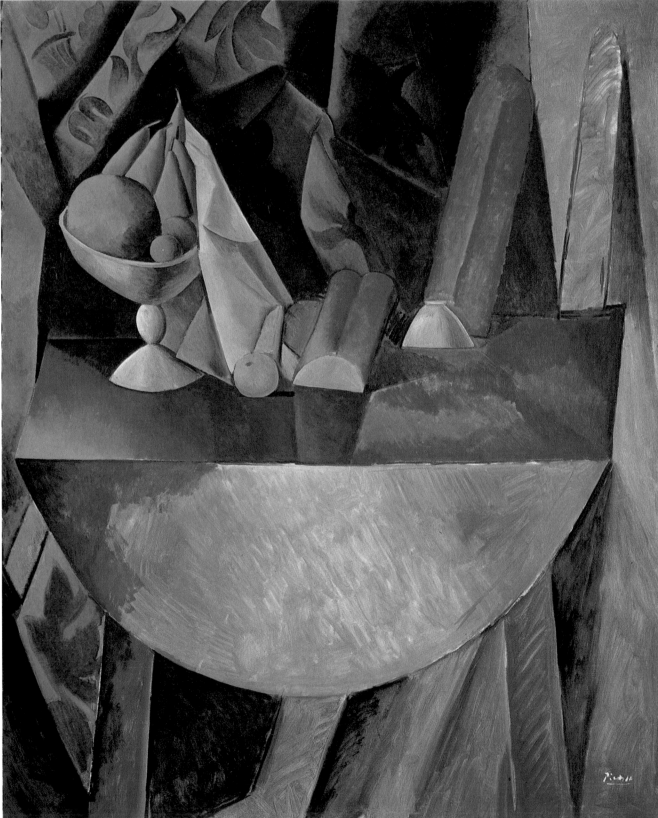

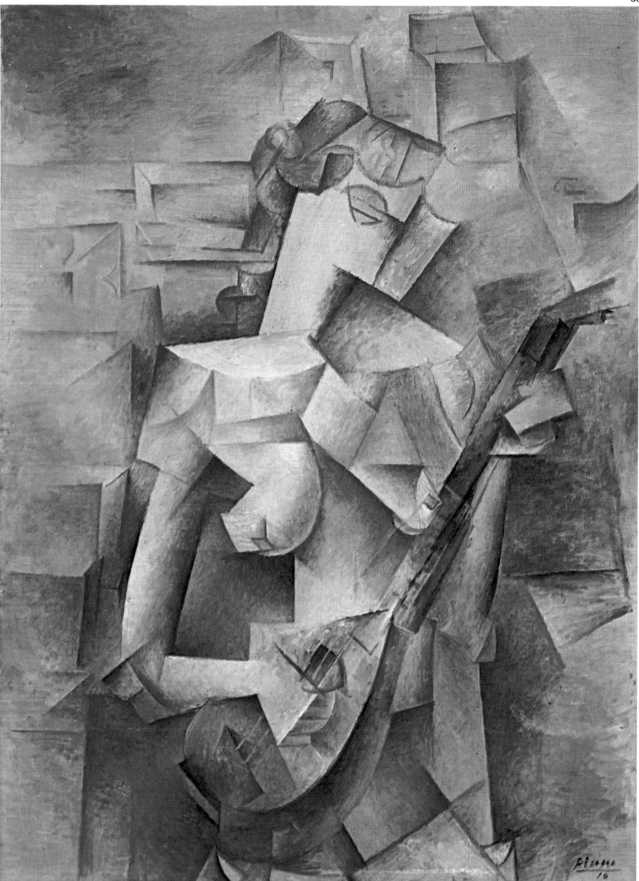

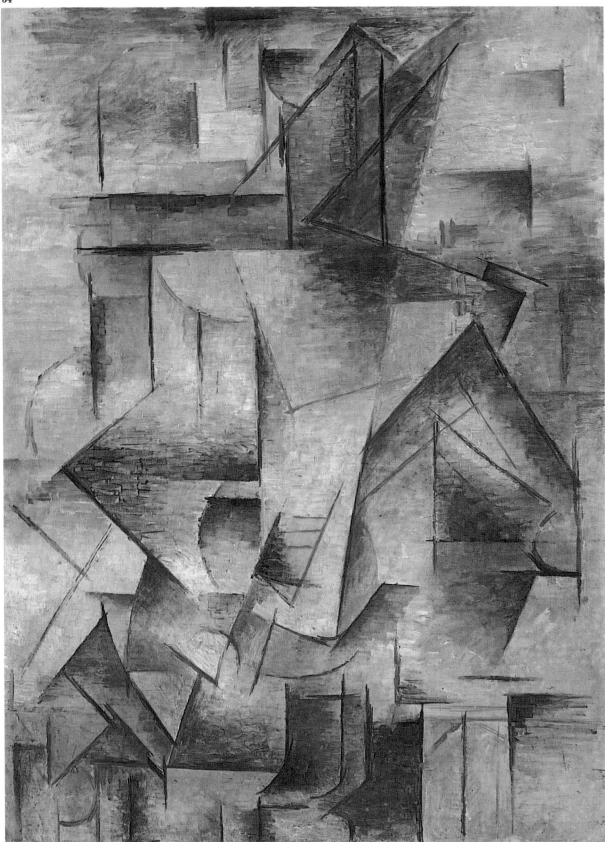

34 The Guitarist, *1910. The contrasts of color have disappeared completely and the canvas is reduced to a simple linear scheme delimited by the planes of the figure, soberly modulated with tiny brushstrokes. By opening up the composition, the artist attempts to lessen the bas-relief effect of the painting and integrate the borders within the surface of the canvas.*

35 Portrait of Daniel-Henry Kahnweiler, *1910. D.-H. Kahnweiler was a German dealer who wagered on Cubism from the very beginning. His portrait is one of the most successful paintings within the realm of Analytical Cubism. The nose, eyes, hands, and the bottle of the still life to the right comprise the figurative clues that permit the viewer to reconstruct the image.*

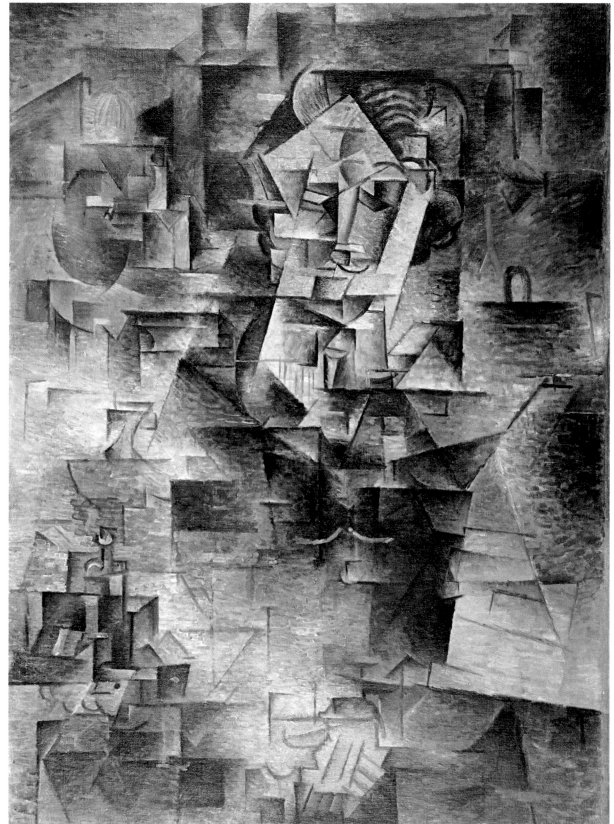

36 Céret Landscape, *1911. Picasso and Georges Braque spent the summer of 1911 painting together in the little town of Céret, located in the Pyrenees. Picasso's work from this period documents his experimentation with the homogeneous depiction of space on the canvas. This exploration lends the paintings of this period a flatter, more integrated appearance and makes their subject matter, which can hardly be recognized, much more difficult to interpret.*

36

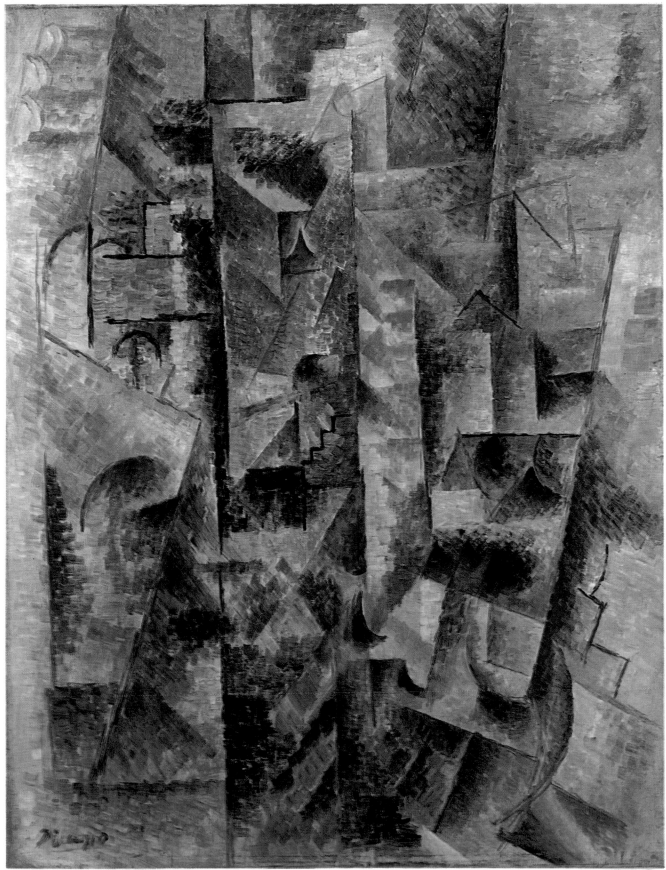

37 The Violin (Jolie Eva), *1912. The title refers to Marcelle Humbert (Eva), Picasso's companion during those years. The imitation of the textures of wood grain with paint is a contribution by Georges Braque, who had experience as a decorator. This treatment serves as a precedent for the papiers collés, which first appeared in 1912. The balance of representation and the planar configuration of space epitomize the main achievement of Analytical Cubism.*

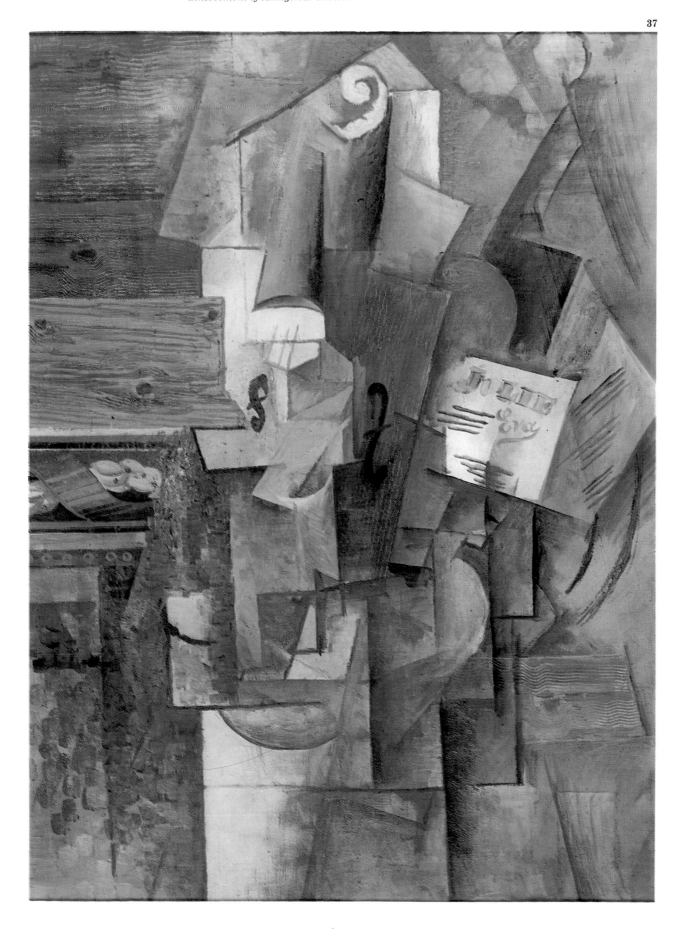

The Painting as Object

By 1912 Cubist expression had matured to the point that it could represent reality by means of non-naturalistic procedures. The next step was taken by Picasso in that same year by incorporating a piece of oilcloth in the guise of chair caning into a still life (fig. 38). Thus were born the *papiers collés*—glued-on papers—the first manifestation of the collage. The application onto the canvas of any matter foreign to the paint marks another of the great contributions of Cubism to modern art. The relationship of the painting to reality becomes increasingly complex, especially because Picasso applied these new artistic gestures with great imagination and irony, avoiding the literal correspondence between the object and its representation. A piece of newspaper, for example, could be transformed into a bottle or a chair, and also serve as the source for a visual pun. Thus the painting itself becomes an object, one more element of reality, endowed with specificity and autonomy.

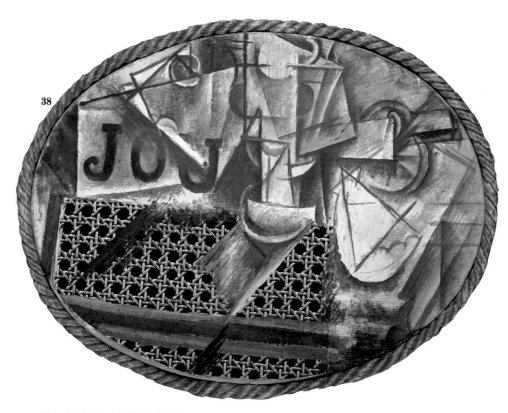

38 Still Life with Chair Caning, *1912. This canvas initiated the technique of* papier collé, *and with it a new twist in the representation of reality within painting. The oval format helps to eliminate spatial ambiguity around the edges.*

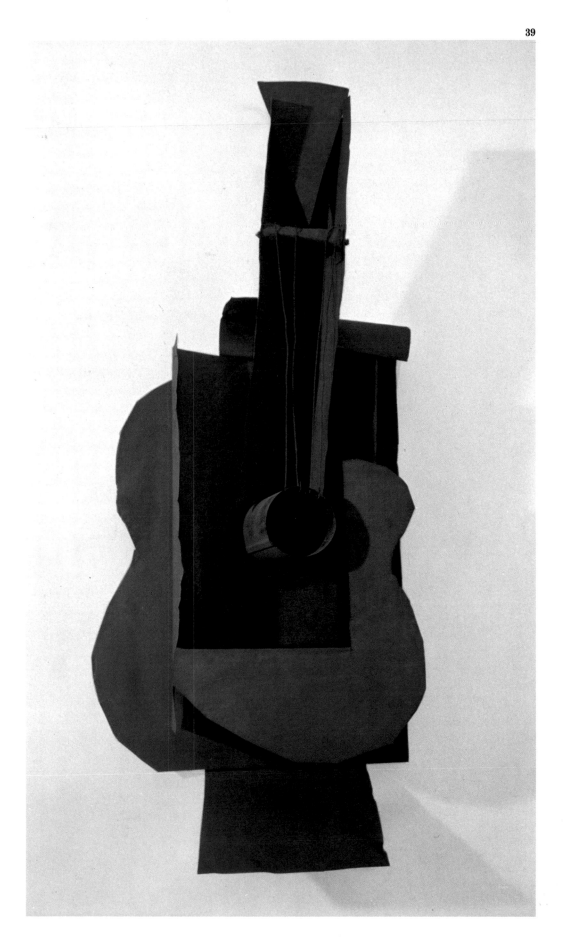

39 Guitar, *1912. This collage introduces ambiguous devices that, apart from their own importance, suggest new possibilities for painting. Thus, the inversion of solid and void, and convex and concave: part of the object—the guitar body—is portrayed by its absence, yet the central opening, a void in reality, is transformed into a projecting cylinder.*

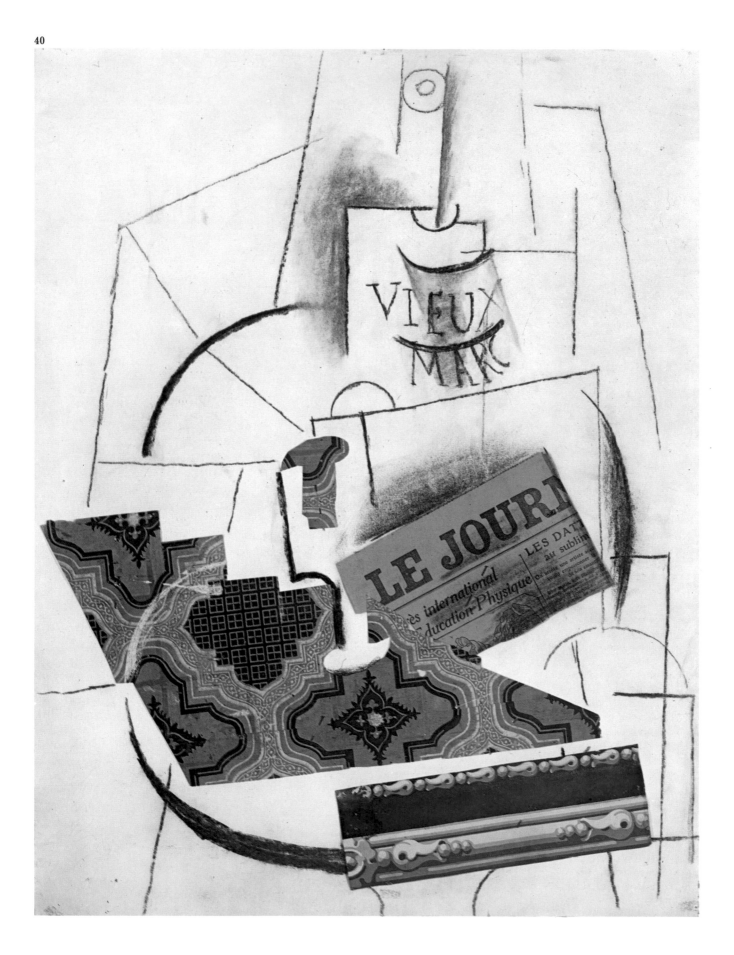

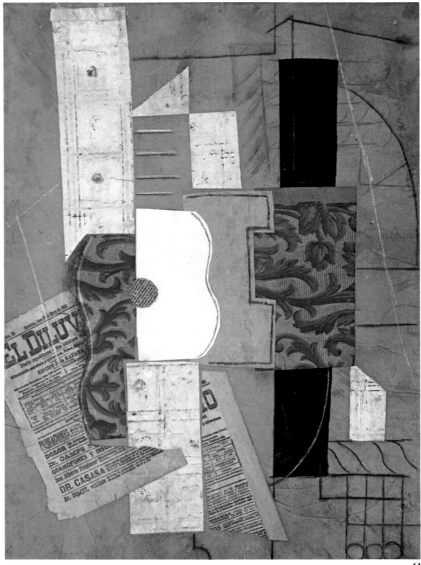

41

42

40 Bottle of Vieux Marc, Glass, and Newspaper, *1913. Picasso extracts the maximum potential from* papiers collés: *while the newspaper represents a real newspaper beside the schematically drawn bottle, two pieces of wallpaper appear to be totally decontextualized and assume a value quite distinct from their typical association.*

41 Guitar, *1913. "If a piece of newspaper can become a bottle, that gives us something to think about with respect to both newspapers and bottles,"* affirmed Picasso about the objective nature of papiers collés. *That displacement of objects is quite evident in the painted paper forming the guitar in this composition.*

42 Head, *1913. The experience with collage and* papier collé *helped Picasso cross the bridge from Analytic Cubism to Synthetic Cubism. In this case, the combination of a triangle and a semicircle produces a figurative association and not the reverse, in which figurative forms are reduced to abstraction, as had occurred before.*

The Maturity of Cubism

Following Georges Braque's enlistment in the armed forces with the onset of World War I in 1914, Picasso continued his quest alone. The conceptual autonomy of the painting achieved with the *papiers collés* came to be a liberation, as the dependency on the subject to drive the work was ever more lessened. In fact, at this stage in Picasso's work, the pictorial process inverts its terms. If the work could allow different materials and textures, for the same reasons it could allow the contrast of color. Thus, between 1914 and 1921 Picasso's canvases exhibit an extremely rich palette. Using a combination of formal, chromatic structures and different textures, figurative associations are attained. The critics baptized this approach Synthetic Cubism, in opposition to the analytical procedure of the previous paintings which constructed a pictorial order from data based on knowledge of the painted object. Cubism thus came full circle and established an artistic language of lasting universal value.

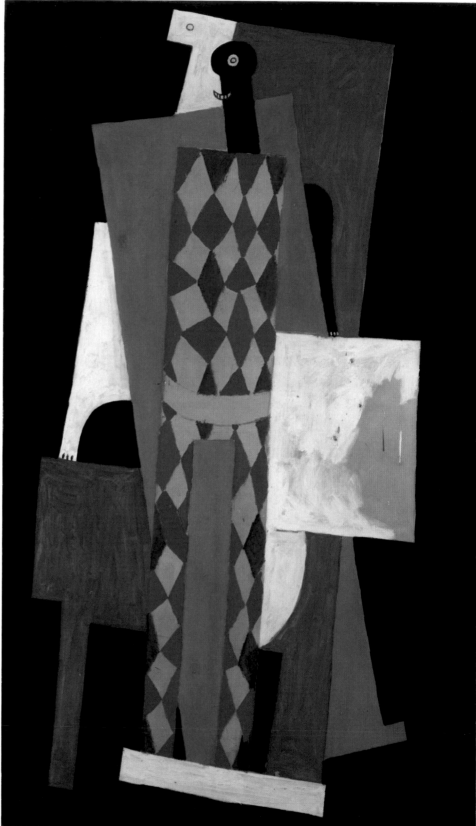

43

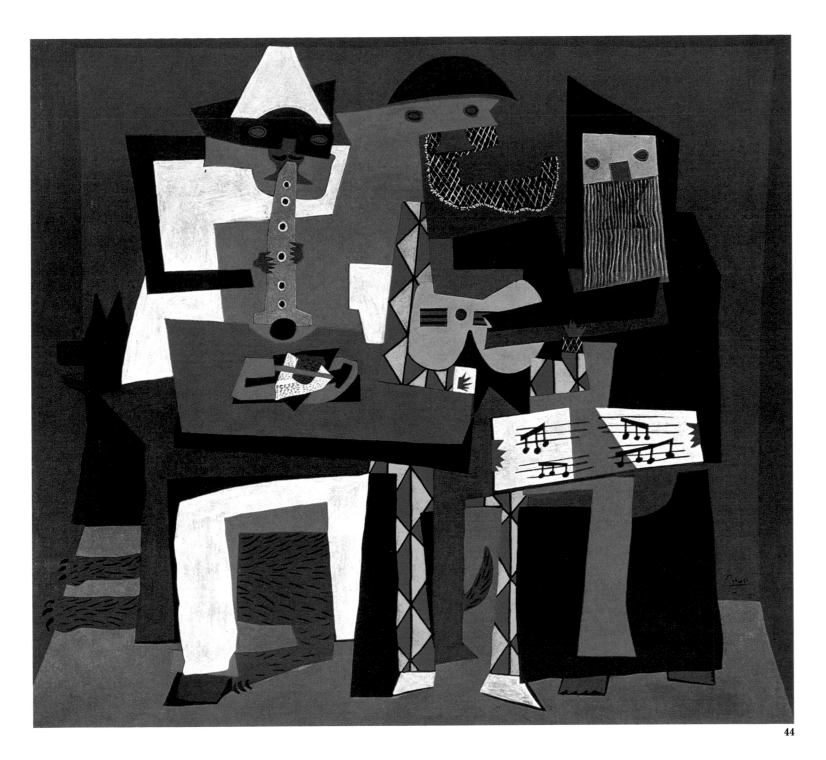

44

43 Harlequin, *1915. A characteristic example of the inversion of
the pictorial process introduced by Synthetic Cubism: displaced
colored surfaces are superimposed and slightly skewed, suggesting
the figure of the harlequin, which is so frequent in Picasso's
canvases.*

44 Three Musicians, *1921. In contrast to the works of Analytical
Cubism, the constructive rigor of these paintings no longer
excludes the incorporation of color or a certain decorative sense
that Picasso learned from his work for Diaghilev's Ballets Russes.
The painter's fidelity to themes like the* commedia dell'arte *was
strong in this period.*

43

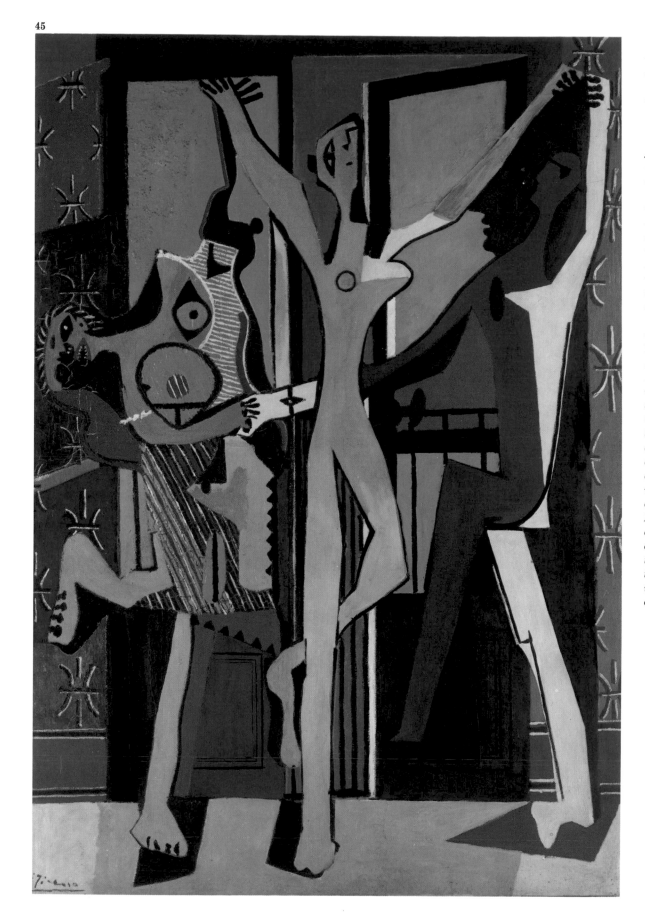

45 The Dance, *1925.*
Apparently this
painting is partly an
homage to Ramón
Pitxot, who had died
shortly before. Some of
the expressionist tone
of the 1930s is
foreshadowed here,
although the most
dominant quality of
the work is the
rhythmic and
syncopated
composition, not
unlike the style of Art
Deco decorative panels,
whose origins are to
be found in canvases
like this one.

46, 47 Glass and
Package of Tobacco,
1924. The Studio,
1927–28. The last
works that can be
characterized as
Cubist stand out
because of their
exacting precision
and flat abstraction,
always achieved
with a minimum
of elements. Thus,
Picasso brought to
a conclusion the
arduous, experimental
task undertaken
twenty years earlier
in Les Demoiselles
d'Avignon.

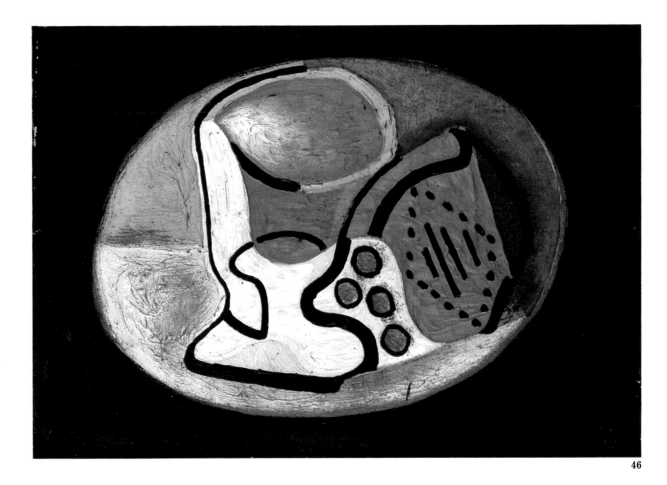

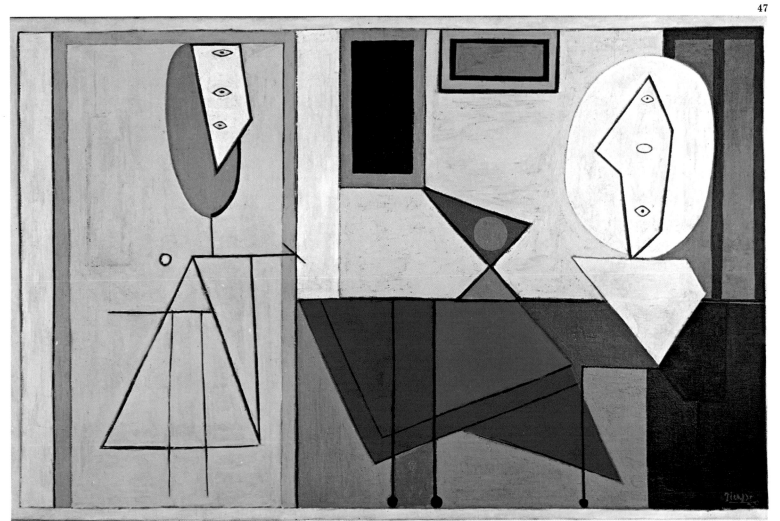

The Return to Order

Following World War I, the artistic scene in Paris seemed to take a rest after the intense outpouring of innovation in the first two decades of the century. For a few years the artistic culture experienced a certain return to traditional values, a trend to which Picasso was not alien. At that time the Spanish painter considered Cubism a complementary alternative that enlarged the domain of painting, but which did not invalidate traditional figurative art. Thus, between 1917 and 1923, Picasso, alternating with Cubist canvases, practiced a certain Mediterranean classicism that revived his interest in form in almost sculptural terms. The influence of Jean-Auguste-Dominique Ingres, the great nineteenth-century French Romantic Classicist, is evident in the precision and discipline of Picasso's drawing from this period. At the end of the 1920s and the beginning of the 1930s Picasso introduced fantastic elements into otherwise conventional pictorial spaces. This, together with the refutation of established reality implicit in the collages, stimulated the interest of the Surrealists in Picasso's work.

48 Sleeping Peasants, *1919. Despite the rotund solidity of the figures, the painting's composition is a delicate arabesque of concentric forms that close on themselves in a spiral, creating a specifically pictorial space that is not incompatible with naturalistic representation.*

49 Woman in Spanish Costume, *1917. The frontal pose of the model and the fluid precision of the drawing have their origin in the portraits of women by J.-A.-D. Ingres. The pointillist color scheme is a means Picasso had already employed in the Cubist paintings of 1913 and 1914, when his palette began to become diversified.*

48

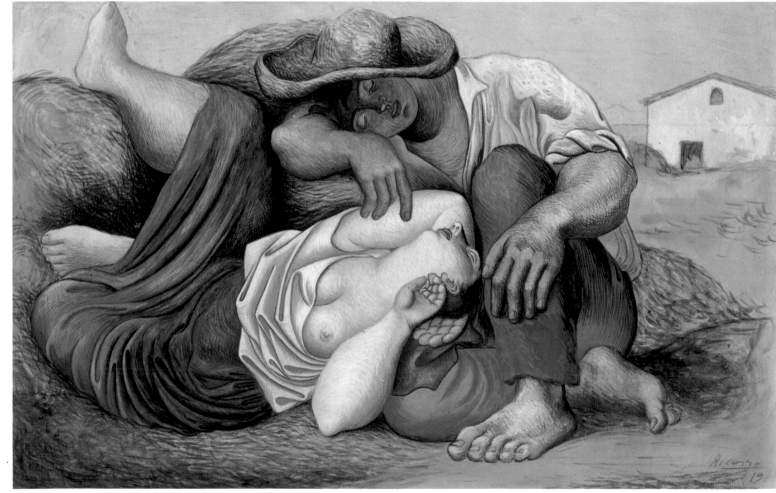

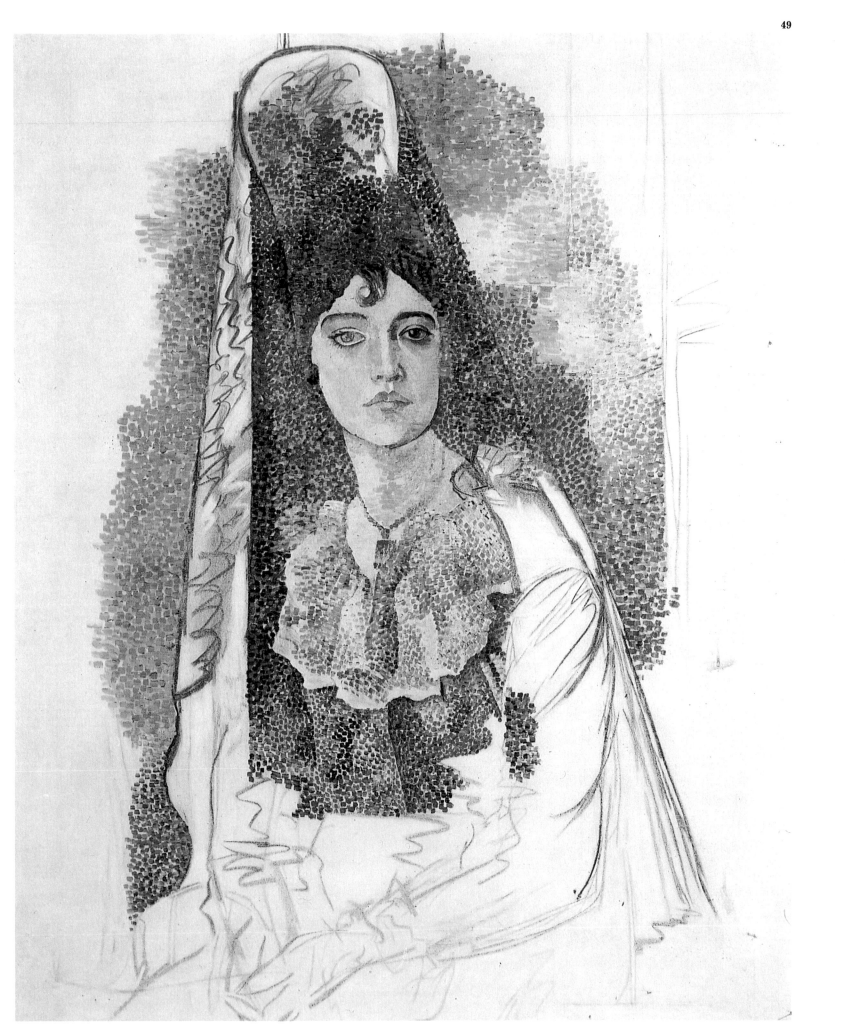

50 Three Women at the Spring, *1921. The figurative format recalls the work of the Blue Period, yet the monumentality reinforces the sculptural quality of Picasso's figurative canvases during these years. A classical reference is very evident in the pyramidal composition of the group and in the figures' subtle gestures. The classically-inspired, pleated tunics evoke the fluted Doric columns of a Greek temple.*

50

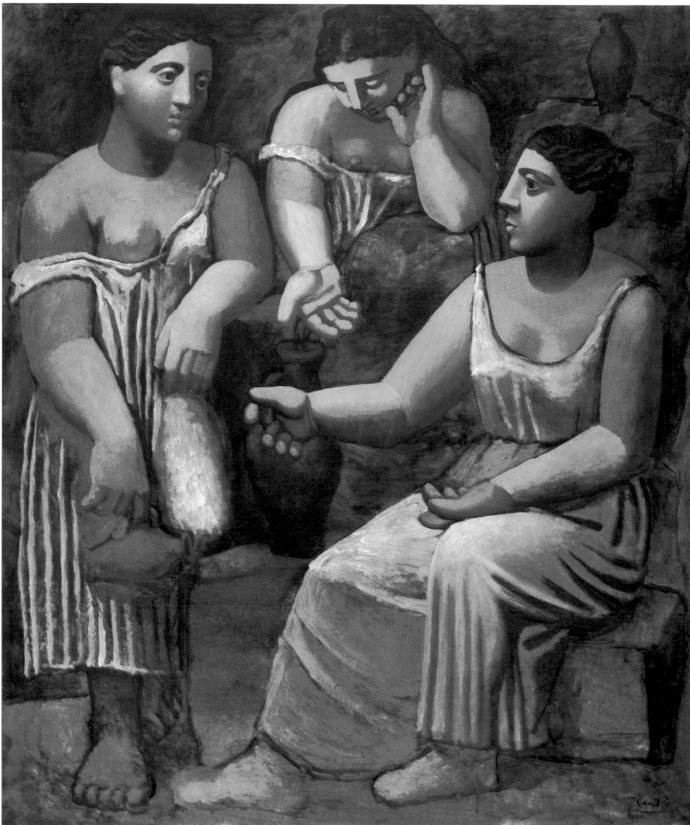

51 Harlequin, *1923. The model for this portrait was the Catalan painter Jacinto Salvadó, a friend of Picasso. The main character of the Italian* commedia dell'arte *always attracted the painter because of its expressive quality. The contrast between the modeled, colored area and the flatter sketch shows Picasso's experimentation in the representation of three-dimensional form, a dominant concern in the figurative work of this period.*

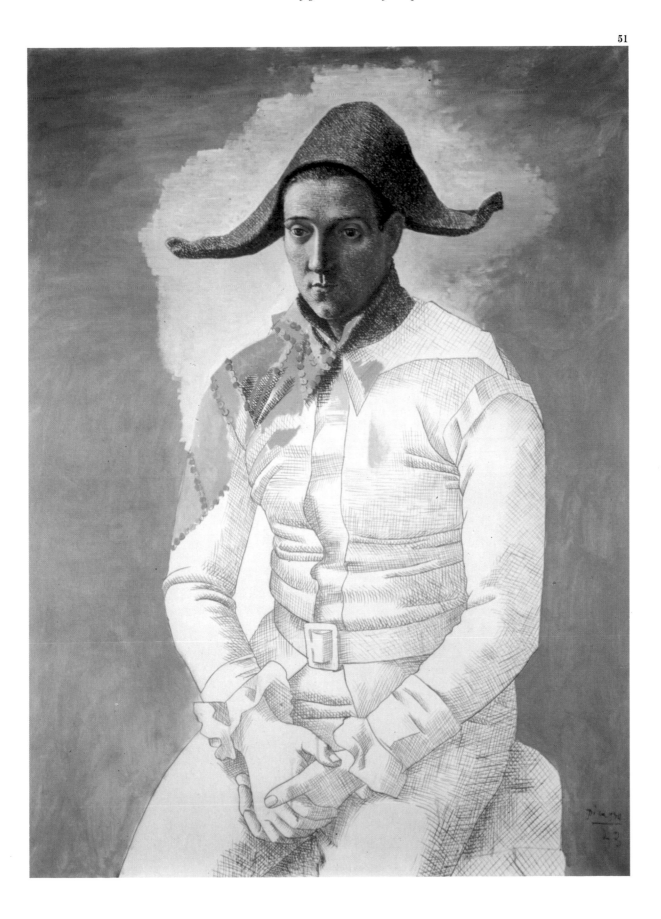

52 Paulo as Harlequin, *1924. Paulo, Picasso's oldest son born from his marriage to ballerina Olga Koklova, was three years old at the time of this portrait. Picasso returned to the theme of the harlequin, which on this occasion is treated in a manner recalling the precise drawings of J.-A.-D. Ingres. The proportions and the composition of the figure in the space recall, nonetheless, Pífano by Edouard Manet and Philip IV's buffoons by Velázquez.*

52

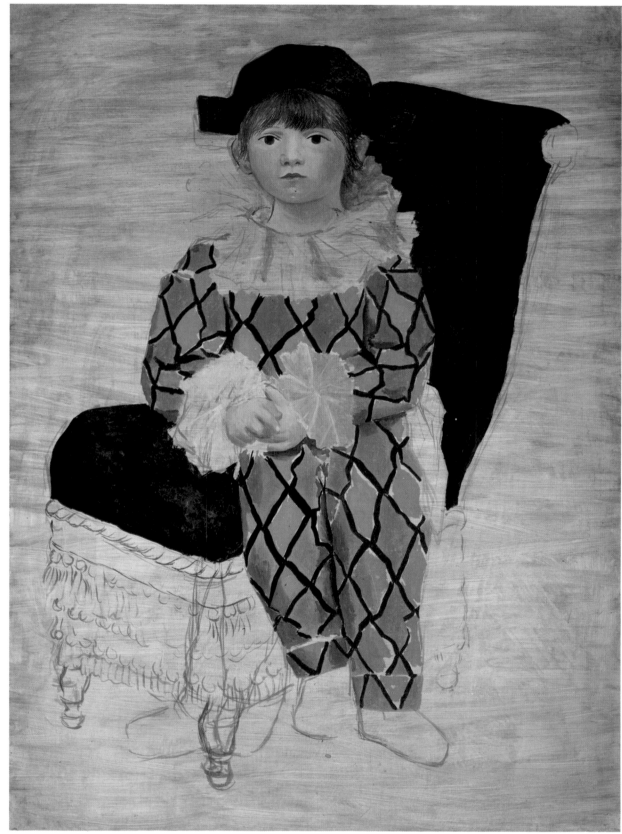

53 Bather with Beach Ball, *1932. In the late 1920s and early 1930s Picasso began to employ devices appropriated from Cubism—such as the overlapping of points of view—in traditional pictorial spaces. This type of painting stimulated the interest of the Surrealists, for whom Picasso had provided conceptual inspiration with collages and* papiers collés.

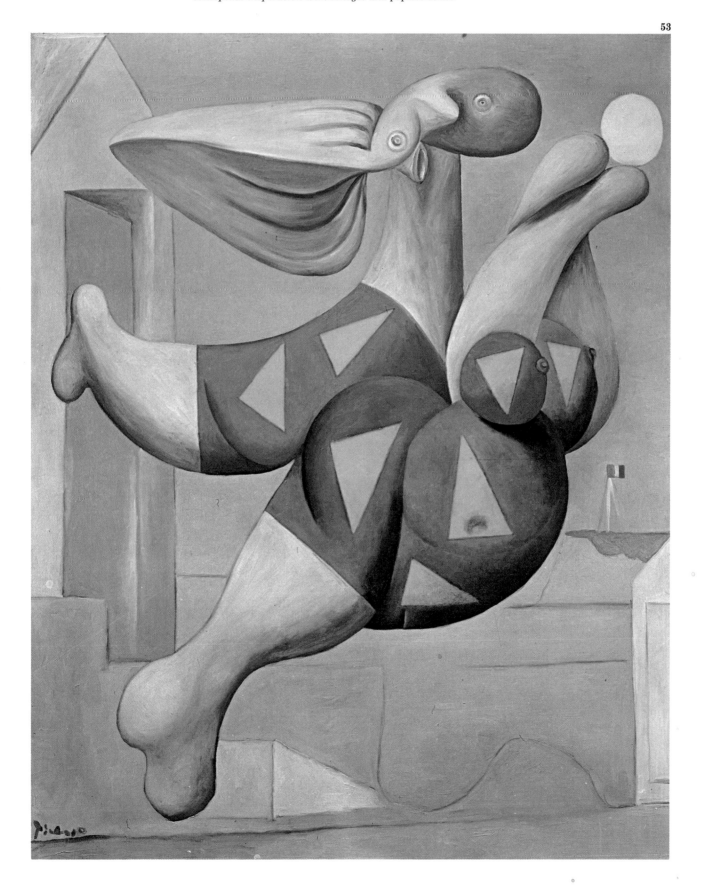

Expressionism and the War

For Spanish artists residing in Paris, such as Joan Miró and Picasso, the decades of the 1930s and 1940s were years of continual upheaval because of the Spanish Civil War and World War II. Picasso's commitment to Spain's legitimate Republican regime heightened the painter's sensitivity to his national heritage. Cubism's devices, like the overlapping of the face both directly and in profile, were now used by Picasso with expressionistic techniques in order to evoke the horror of war. The peculiar Picassoesque expressionism which developed in this period is encountered later in the work of other, more recent painters like Francis Bacon or Lucien Freud. This period's touchstone is the monumental canvas, *Guernica* (1937), painted in reaction to the devastating bombardment perpetrated by the German military on a small Basque town. This great mural was the star attraction of the Spanish Pavilion in the 1937 World's Fair in

54

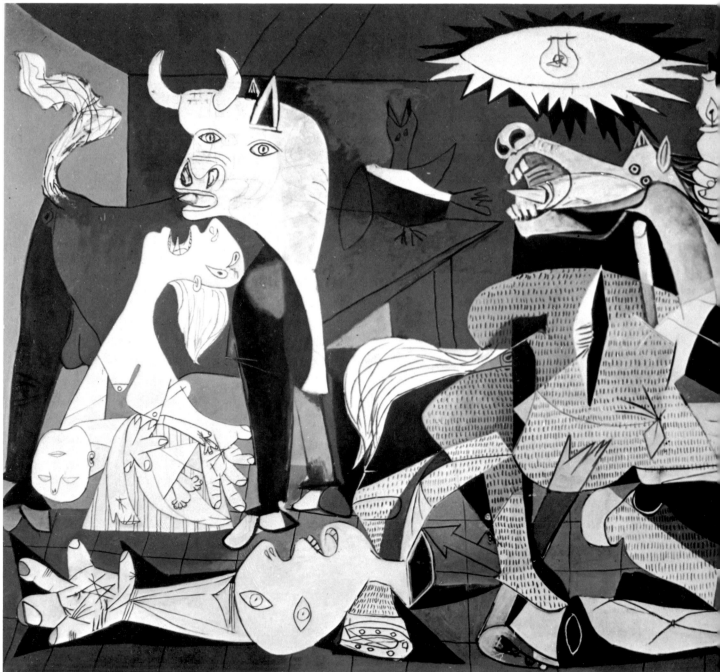

Paris, to which artists like Joan Miró, Alberto Sánchez, Julio González, Alexander Calder, and Josep Lluís Sert (the architect in charge of the project, along with Luis Lacasa) also contributed.

54 Guernica, *1937. The German air force bombed Guernica on April 26, 1937, prompting a massacre of the civilian population. Picasso was so moved by this tragedy that in just less than a month he had completed this monumental work, preceded by a great number of sketches and preparatory studies. A series of emblematic figures evokes the horror of the event: the bull, the wounded horse—symbolizing the innocent civilian victims—the decapitated warrior, the wail of a mother with her dead child in her arms. The composition of the space is Cubist in origin, as is the treatment of many of the figures. The renunciation of color also has an expressive function. Never before, from* The Death of Marat *by Jacques-Louis David or* The Massacre at Chios *by Eugène Delacroix, had painting achieved such a universal expression of the drama of contemporary events.*

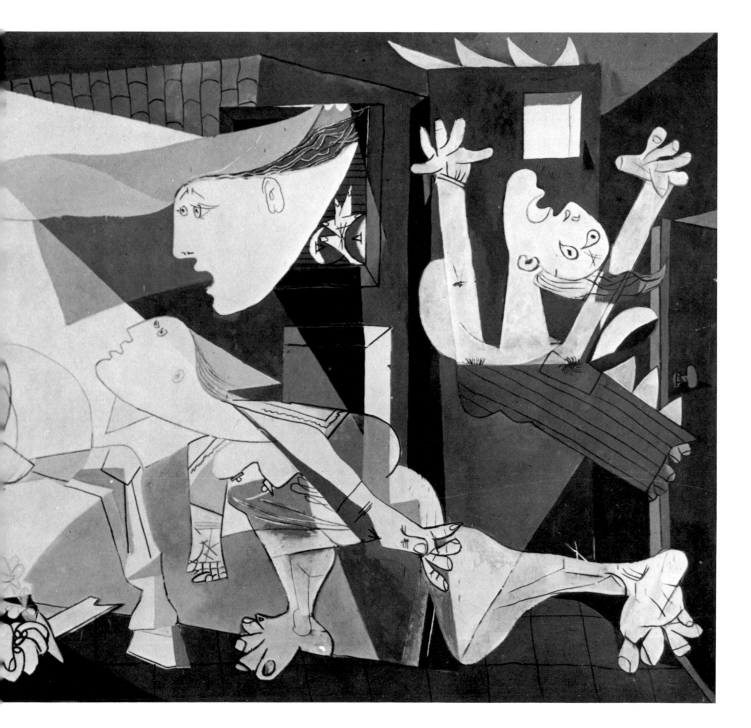

55 Weeping Woman, *1937. The expressive devices employed in Guernica again return to the canvas. Color—greens and acrid yellows—also serves an expressionist function in Picasso's work of those years, much of which was dedicated to conveying the heightened drama and tension of the era.*

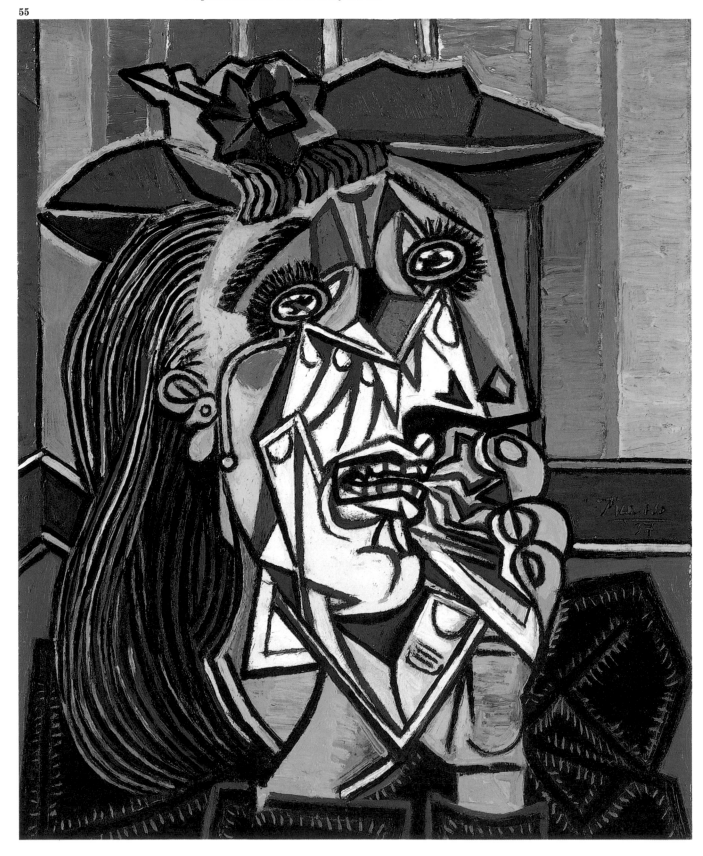

56 Woman Dressing Her Hair, *1940. The composition recalls the
surrealistic scenes of the late 1920s and the early 1930s: a
traditional orthogonal space inhabited by an unsettling figure
taken from Cubism, which is no longer an experimental method,
but rather an expressive means to evoke monsters.*

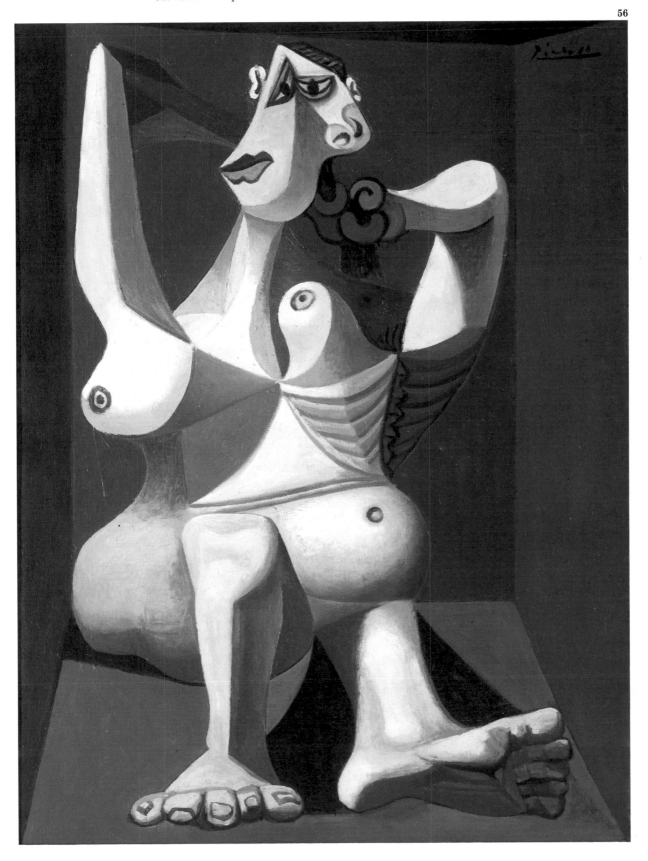

The Maids of Honor (Las Meninas)

From among Picasso's abundant output in the postwar period, two inter-related series of paintings are particularly significant. The 1956 work *The Studio* (series) and *The Maids of Honor (Las Meninas)* of the following year represent interior views of his house and studio La Californie, in Cannes, where he had lived with Françoise Gilot, the mother of his two youngest children. During the years in which these works were painted, the period between breaking up with Françoise and establishing a relationship with his last companion, Jacqueline Roque, Picasso found himself alone. Solitude—to which the painter was not accustomed—led him to re-create those quiet, intimate interiors, empty yet bathed in dazzling Mediterranean light. On a few occasions such as this one, Picasso surrendered to the pure pleasure of painting, lingering on the vibration of color on the canvas, almost as in the paintings of Henri Matisse to whom *The Studio* series is an homage. Velázquez served Picasso as an intermediary in *The Maids of Honor (Las Meninas)*, an homage that the painter used to veil the autobiographical quality of the paintings.

57 The Studio of La Californie, *1956. Space is re-created in strictly visual terms, using solid patches of color extended over the canvas, which is left white and without prior priming.*

57

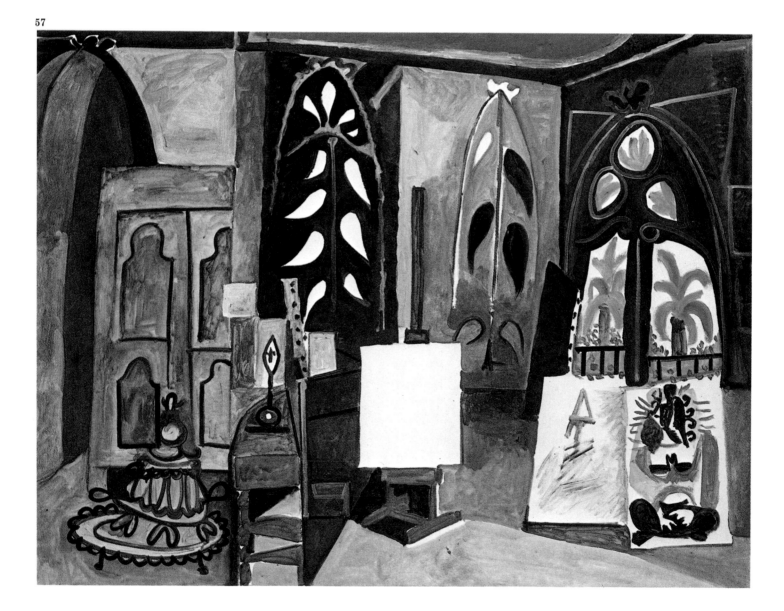

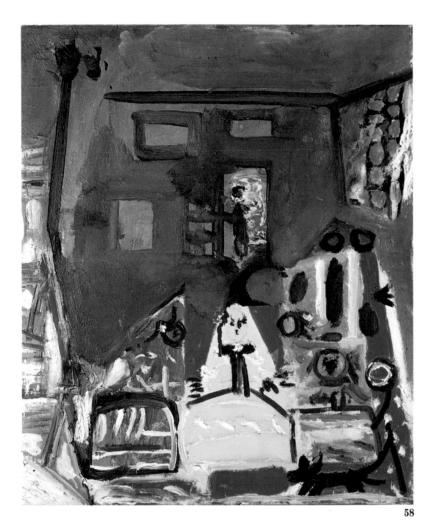

58

58 The Maids of Honor (Las Meninas), after Vélazquez, *1957. Color individualizes the figures against the gray and bluish tones of the room's shadows.*

59 Las Meninas (The Doves, 5), *1957. Picasso's fixation with pigeons goes back to his childhood in Málaga, where his father often used them as a subject in his drawings.*

60 The Maids of Honor (Las Meninas), *1957. The saturated red background against which the figures float recalls certain paintings by Henri Matisse, with whom Picasso had frequent contact during the years spent in Nice.*

60

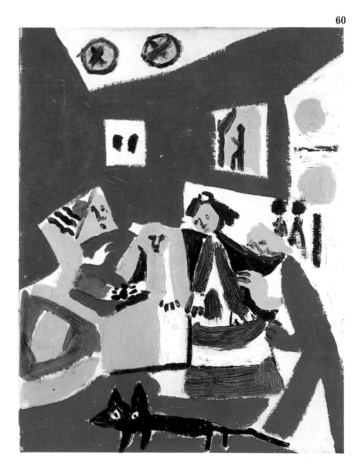

59

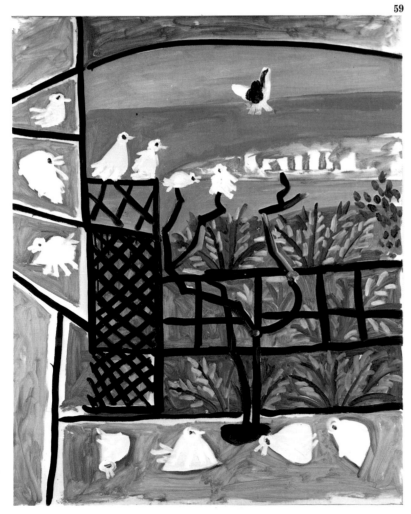

Overleaf
61 Las Meninas, *1957. The last painting of the series most closely follows the dark, luminous hues and fluid brushstrokes of Velázquez.*

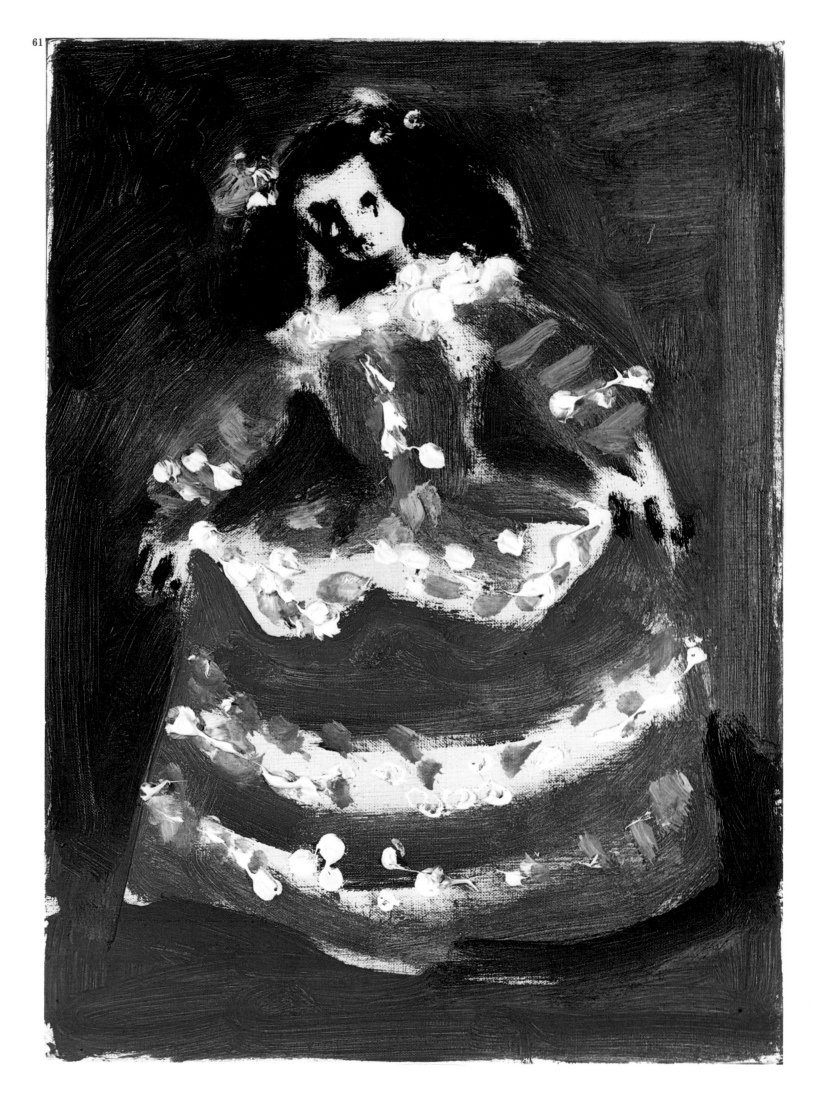

The Freedom of Painting

The last years of Picasso's life and work bequeathed to posterity an image of mythic vitality, difficult to imagine in a man who died at the age of ninety-two. His creative production between 1960 and 1973 is quite extensive and encompasses all mediums, from linoleum engraving and etching to easel painting and sculpture. The common denominator in his late work is the freedom of execution. From the re-creation of past masters to a jovial use of color to caricaturesque expressionism, the mastery that accompanied Picasso from his youthful, academic studies was now transformed into an authentic celebration of painting in itself.

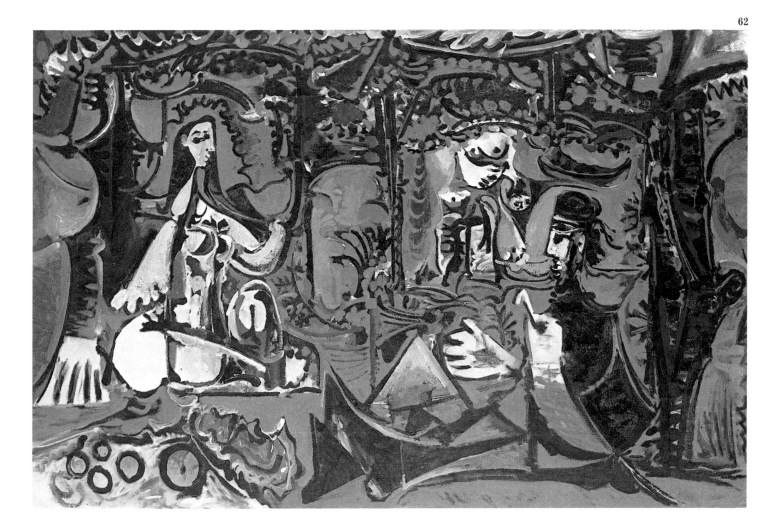

62 Luncheon on the Grass, after Manet, *1960. Picasso re-created the famous painting by Edouard Manet, using a similar chromatic scale, but darker and colder, and reproducing its horizontal composition with bands of color.*

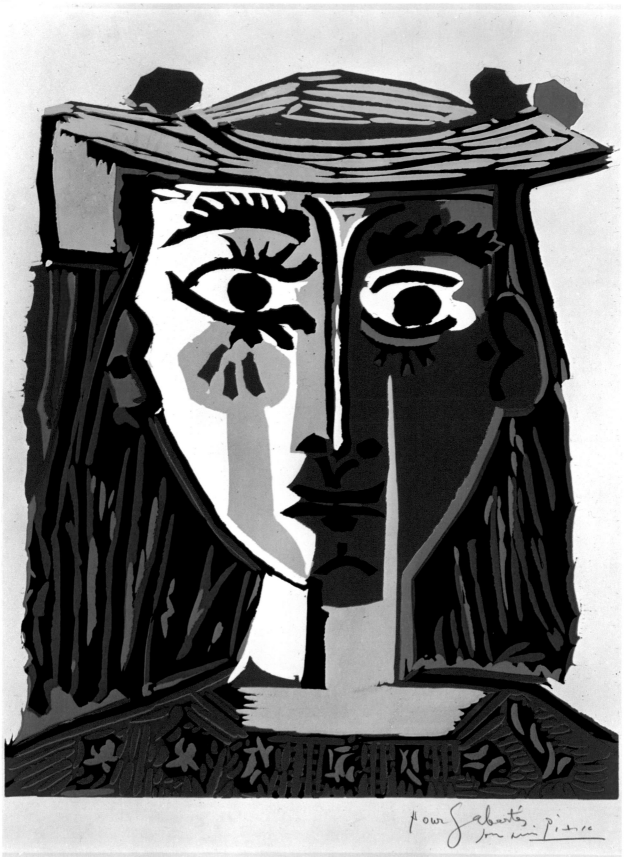

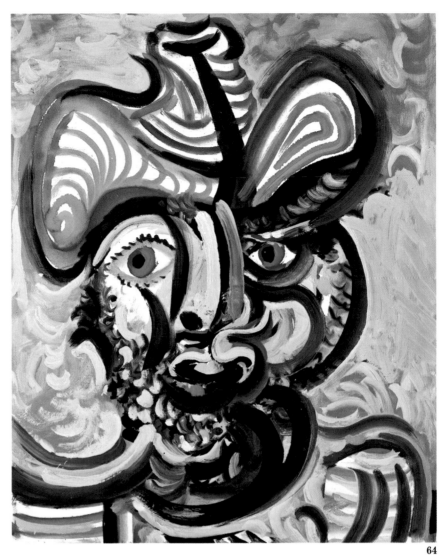

63 Woman with Hat, *1962. The linoleum cuts represent one of the few innovations in technique from Picasso's later period. As was customary, the painter extracted the maximum impact from the graphic possibilities of this procedure. The visual force of the image is attained by the fusion of drawing and color into a single gesture.*

64, 65 Character, *1972.* Head of a Man, *1972. These two busts, painted barely a year before Picasso's death, constitute pure recreation in the mastery of pictorial gesture. Despite their apparent spontaneity, the degree of control in drawing and composition is extraordinary for a ninety-year-old person.*

64

65

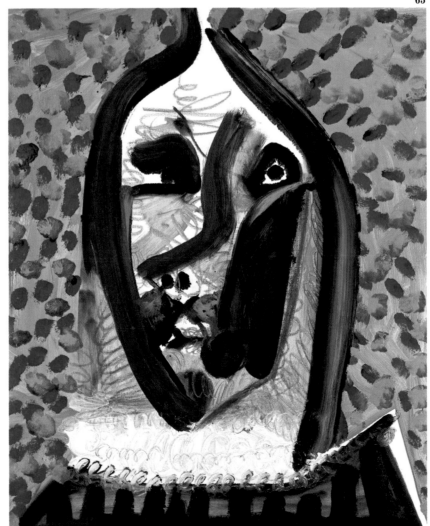

List of Plates

1 The Farm at Quiquet, *Puertos de Horta, Summer 1898. Oil on canvas, 11 × 14⅓" (27.7 × 36.4 cm). Museo Picasso, Barcelona*

2 The Sick Woman, *La Coruña, 1894. Oil on wood, dimensions unknown. Estate of the artist*

3 Science and Charity, *Barcelona, 1897. Oil on canvas, 77⅝ × 98¼" (197 × 249.4 cm). Museo Picasso, Barcelona*

4 Female Nude, *Paris, Spring–Summer 1901. Oil on canvas, 27½ × 35½" (70 × 90.2 cm). Musée National d'Art Moderne, Centre Georges Pompidou, Paris*

5 Poster for the Menu of Els Quatre Gats, *Barcelona, 1900. Pen and ink, 8⅝ × 6¼" (22 × 16 cm). Whereabouts unknown*

6 Sabartés, "Decadent Poet," *1900. Charcoal and watercolor on paper, 19 × 12½" (48 × 32 cm). Museo Picasso, Barcelona*

7 The Manola (Inspired by Lola Ruiz Picasso), *Barcelona, 1900. Pastel, 17½ × 8⅜" (44.5 × 21 cm). Collection Barbara Thurston, New York*

8 Street Embrace, *Paris, 1900. Pastel on paper, 23¼ × 13¾" (59 × 35 cm). Museo Picasso, Barcelona*

9 Two Female Figures, *Paris, 1900. Watercolor and ink on paper, 5¼ × 8" (13.4 × 20.3 cm). Museo del "Cau Ferrat," Sitges (Barcelona)*

10 The Red Skirt, *Paris, 1901. Pastel on paper, 21⅝ × 18½" (55 × 47 cm). Private Collection, Tokyo*

11 Bullfight Scene, *Barcelona, Spring 1901. Oil on cardboard mounted on wood, 19½ × 25½" (49.5 × 64.7 cm). Collection Stavros S. Niarchos, Saint-Moritz*

12 Bullfighters and Bull in Anticipation, *Barcelona, 1900. Pastel and wash, 6⅜ × 12¼" (16.2 × 30.5 cm). Museo del "Cau Ferrat," Sitges (Barcelona)*

13 Woman with a Scarf, *Barcelona, 1902. Oil on canvas, 24⅞ × 20⅝" (63 × 52.4 cm). Marina Picasso Foundation*

14 Boy with Dog, *Paris, 1905. Gouache, 22⅜ × 16⅛" (57 × 41 cm). Hermitage Museum, St. Petersburg*

15 Self-Portrait, *Paris, end of 1901. Oil on canvas, 31½ × 23⅝" (80 × 60 cm). Musée Picasso, Paris*

16 Maternity Beside the Sea, *Barcelona, 1902. Oil on canvas, 32⅝ × 23⅝" (83 × 60 cm). Collection H. and E. Beyeler, Basel*

17 La Vie, *Barcelona, Spring–Summer 1903. Oil on canvas, 77⅜ × 50⅝" (196.5 × 128.5 cm). The Cleveland Museum of Art. Gift of the Hanna Fund, 1945*

18 The Madman, *Barcelona, 1904. Blue watercolor on wrapping paper, 33⅞ × 14⅛" (86 × 36 cm). Museo Picasso, Barcelona*

19 Couple with Child at the Café, *Barcelona, 1903. Pen on paper, 8⅝ × 6¼" (21.9 × 16 cm). Private Collection, Barcelona*

20 Casagemas Nude, *Barcelona, 1904. Pen and blue pencil, 5¼ × 3½" (13.3 × 9 cm). Private Collection, Barcelona*

21 Meditation (Contemplation), *Paris, Autumn 1904. Watercolor and pen, 13⅝ × 10⅛" (34.6 × 25.7 cm). Collection Mrs. Bertram Smith, New York*

22 The Acrobat's Family with a Monkey, *Paris, 1905. Gouache, watercolor, pastel, and India ink on cardboard, 41 × 29½" (104 × 75 cm). Göteborgs Kunstmuseum*

23 Acrobat on a Ball, *Paris, 1905. Oil on canvas, 57⅞ × 37⅜" (147 × 95 cm). Pushkin Museum of Fine Arts, Moscow*

24 Family of Acrobats, *Paris, 1905. Gouache on cardboard, 20⅛ × 24" (51.2 × 61.2 cm). Pushkin Museum of Fine Arts, Moscow*

25 Amazon on Horseback, *Paris, 1905. Gouache on cardboard, 23⅝ × 31⅛" (60 × 79 cm). Estate of the artist*

26 La Toilette, *Gosol, Spring–Summer 1906. Oil on canvas, 59½ × 39" (151 × 99 cm). Albright-Knox Art Gallery, Buffalo*

27 Les Demoiselles d'Avignon, *Paris, Spring–Summer 1907. Oil on canvas, 96 × 92" (243.9 × 233.7 cm). The Museum of Modern Art, New York. Acquired through the Lillie P. Bliss Bequest*

28 Two Nudes, *Paris, Autumn–Winter 1906. Oil on canvas, 59⅝ × 36⅝" (151.3 × 93 cm). The Museum of Modern Art, New York. Gift of G. David Thompson in honor of Alfred H. Barr, Jr.*

29 Portrait of Gertrude Stein, *begun Winter 1905–06; partially reworked Autumn 1906. Oil on canvas, 39¼ × 32" (99.6 × 81.3 cm). The Metropolitan Museum of Art, New York. Bequest of Gertrude Stein*

30 Landscape with Two Figures, *1908. Oil on canvas, 22⅞ × 28⅜" (58 × 72 cm). Musée Picasso, Paris*

31 The Reservoir, Horta de Ebro, *Horta de Ebro, Summer 1909. Oil on canvas, 31⅞ × 25⅝" (81 × 65 cm). Private Collection, Paris*

32 Bread and Fruit Dish on a Table, *Paris, early 1909. Oil on canvas, 64⅝ × 52¼" (164 × 132.5 cm). Kunstmuseum, Basel*

33 Girl with a Mandolin, *Paris, early 1910. Oil on canvas, 39½ × 29" (100.3 × 73.6 cm). The Museum of Modern Art, New York. Nelson A. Rockefeller Bequest*

34 The Guitarist, *Cadaqués, Summer 1910. Oil on canvas, 39⅜ × 28¾" (100 × 73 cm). Musée National d'Art Moderne, Centre Georges Pompidou, Paris*

35 Portrait of Daniel-Henry Kahnweiler, *Paris, 1910. Oil on canvas, 39⅝ × 25⅝" (100.6 × 72.8 cm). The Art Institute of Chicago. Gift of Mrs. Gilbert W. Chapman in memory of Charles B. Goodspeed*

36 Céret Landscape, *Céret, Summer 1911. Oil on canvas, 25⅝ × 19¾" (65 × 50 cm). The Solomon R. Guggenheim Museum, New York*

37 The Violin (Jolie Eva), *Céret, Spring 1912. Oil on canvas, 31⅞ × 23⅝" (81 × 60 cm). Staatsgalerie, Stuttgart*

38 Still Life with Chair Caning, *Paris, May 1912. Collage of oil, oilcloth, and paper on canvas (oval), framed with rope, 10⅝ × 13¾" (27 × 35 cm). Musée Picasso, Paris*

39 Guitar, *Paris, early 1912. Sheet metal and wire, 30½ × 13¾ × 7⅝" (77.5 × 35 × 19.3 cm). The Museum of Modern Art, New York. Gift of the artist*

40 Bottle of Vieux Marc, Glass, and Newspaper, *Céret, 1913. Charcoal and pasted paper, 24⅝ × 18½" (62.5 × 47 cm). Musée National d'Art Moderne, Centre Georges Pompidou, Paris*

41 Guitar, *Céret, Spring 1913. Charcoal, crayon, ink, and pasted paper, 26⅛ × 19½" (66.3 × 49.5 cm). The Museum of Modern Art, New York. Nelson A. Rockefeller Bequest*

42 Head, *Paris or Céret, early 1913. Charcoal and pasted paper on cardboard, 16⅛ × 12⅝" (41 × 32 cm). Private collection, London*

43 Harlequin, *Paris, late 1915. Oil on canvas, 72¼ × 41⅜" (183.5 × 105.1 cm). The Museum of Modern Art, New York. Acquired through the Lillie P. Bliss Bequest*

44 Three Musicians, *Fontainebleau, Summer 1921. Oil on canvas, 79 × 87¾" (200.7 × 222.9 cm). The Museum of Modern Art, New York. Mrs. Simon Guggenheim Fund*

45 The Dance, *Monte Carlo, June 1925. Oil on canvas, 84⅝ × 55⅞" (215 × 142 cm). The Tate Gallery, London*

46 Glass and Package of Tobacco, *Paris, 1924. Oil on canvas, 6 × 8⅝" (16 × 22 cm). Museo Picasso, Barcelona*

47 The Studio, *Paris, Winter 1927–28. Oil on canvas, 59 × 91" (149.9 × 231.2 cm). The Museum of Modern Art, New York. Gift of Walter P. Chrysler, Jr.*

48 Sleeping Peasants, *Paris, 1919. Tempera, watercolor, and pencil, 12¼ × 19¼" (31.1 × 48.9 cm). The Museum of Modern Art, New York. Abby Aldrich Rockefeller Fund*

49 Woman in Spanish Costume (La Salchichona), *Barcelona, 1917. Oil on canvas, 45⅝ × 35⅛" (116 × 89 cm). Museo Picasso, Barcelona*

50 Three Women at the Spring, *Fontainebleau, Summer 1921. Oil on canvas, 80¼ × 68½" (203.9 × 174 cm). The Museum of Modern Art, New York. Gift of Mr. and Mrs. Allan D. Emil*

51 Harlequin (Portrait of the Painter Jacinto Salvadó), *Paris, 1923. Oil on canvas, 51¼ × 38¼" (130 × 97 cm). Musée National d'Art Moderne, Centre Georges Pompidou, Paris*

52 Paulo as Harlequin, *Paris, 1924. Oil on canvas, 51¼ × 38⅜" (130 × 97.5 cm). Musée Picasso, Paris*

53 Bather with Beach Ball, *Boisgeloup, August 30, 1932. Oil on canvas, 57⅝ × 45⅛" (146.2 × 114.6 cm). The Museum of Modern Art, New York. Mr. and Mrs. Joseph H. Lauder Collection*

54 Guernica, *May 1–June 4, 1937. Oil on canvas, 11' 5½" × 25' 5¾" (349.3 × 776.6 cm). Museo Nacional Centro de Arte Reina Sofía, Madrid*

55 Weeping Woman, *Paris, October 26, 1937. Oil on canvas, 23⅝ × 19¼" (60 × 49 cm). Private Collection, England*

56 Woman Dressing Her Hair, *Royan, June 1940. Oil on canvas, 51¼ × 38¼" (130 × 97 cm). Collection Mrs. Bertram Smith, New York*

57 The Studio of La Californie, *Cannes, March 30, 1956. Oil on canvas, 44⅞ × 57½" (114 × 146 cm). Musée Picasso, Paris*

58 The Maids of Honor (Las Meninas), after Velázquez, *Cannes, September 4, 1957. Oil on canvas, 18⅛ × 14¾" (46 × 37.5 cm). Museo Picasso, Barcelona*

59 Las Meninas (The Doves, 5), *Cannes, September 7, 1957. Oil on canvas, 39⅜ × 31½" (100 × 80 cm). Museo Picasso, Barcelona*

60 The Maids of Honor (Las Meninas), *Cannes, November 17, 1957. Oil on canvas, 13¾ × 10⅝" (35 × 27 cm). Museo Picasso, Barcelona*

61 Las Meninas (Isabel de Velasco), *Cannes, December 30, 1957. Oil on canvas, 13 × 9½" (33 × 24 cm). Museo Picasso, Barcelona*

62 Luncheon on the Grass, after Manet, *Vauvenargues, March 3–August 20, 1960. Oil on canvas, 50⅞ × 76¾" (129 × 195 cm). Musée Picasso, Paris*

63 Woman with Hat, *1962. Linoleum cut, 25 × 20¾" (63.5 × 52.5 cm). Museo Picasso, Barcelona*

64 Character, *Mougins, January 19, 1972. Oil on canvas, 39⅜ × 31⅞" (100 × 81 cm)*

65 Head of a Man, *Mougins, April 30, 1972. Oil on canvas, 31⅞ × 25⅝" (81 × 65 cm)*

Editor, English-language edition: Elisa Urbanelli
Designer, English-language edition: Judith Michael

Page 1 Caricature of the Artist. *1903.*
Pen and ink, 4⅝ × 4¼″ (11.8 × 10.7 cm).
Museo Picasso, Barcelona

Library of Congress Catalog Card Number: 94–79670
ISBN 0–8109–4690–4

Copyright © 1994 Globus Comunicación, S.A., and Ediciones Polígrafa, S.A.
Reproductions copyright © 1994 Pablo Picasso/VEGAP, Barcelona
English translation copyright © 1995 Harry N. Abrams, Inc.

Published in 1995 by Harry N. Abrams, Incorporated, New York
A Times Mirror Company
All rights reserved. No part of the contents of this book may be reproduced
without the written permission of the publisher

Printed and bound in Spain by La Polígrafa, S.L.
Parets del Vallès (Barcelona)
Dep. Leg.: B. 1.893-1995